IMAGES
of America

REVERE

IMAGES
of America

REVERE

William J. Craig
with the Revere Society for Cultural and Historic Preservation

ARCADIA
PUBLISHING

Published by Arcadia Publishing
Charleston SC, Chicago IL, Portsmouth NH, San Francisco CA

Printed in the United States of America

Library of Congress Catalog Card Number: 2004108610

For all general information contact Arcadia Publishing at:
Telephone 843-853-2070
Fax 843-853-0044
E-mail sales@arcadiapublishing.com
For customer service and orders:
Toll-Free 1-888-313-2665

Visit us on the Internet at www.arcadiapublishing.com

*To the citizens of Revere, past and present, who
through their strong leadership, sacrifice, and devotion, have
dedicated their lives to ensuring that the founding principles upon
which the city was built will be preserved for future generations.*

CONTENTS

ACKNOWLEDGMENTS

An endeavor of this magnitude would never have been able to be completed without the tireless efforts of a multitude of individuals throughout the years. The members of the Revere Society for Cultural and Historic Preservation (RSCHP) would like to extend their sincerest gratitude to the following: the Community Development Corporation, our founding members, Marie Alessi, Robert Alessi, Ralph DiPrisco, Dorothy Dipesa, Ralph Dipesa, Mary DiOlimpio, Ann Fedele, Steve Hagan, Joe James, Fred Leyden, Marilyn Leyden, Margaret Nazzaro, Elsie Palermo, Joe Palermo, Robert Sasso, and William Sasso. Special recognition is extended to attorney Richard Dipesa and the members of the RSCHP Advisory Board.

The 100-year-old museum building, located at 108 Beach Street, has been preserved as a significant historic asset and saved for future generations thanks to the many people who supported the society during this unsettling period of keeping the wrecking ball away. Those people include former mayor Robert Haas, past councilors who voted in favor of the preservation project, George Colella, George Caporale, John Jordan, Paul Buonfiglio, Joseph Dicarlo, and Richard Penn, city planner Frank Stringi, the local press, the Massachusetts Historic Commission, and the society's many donors.

I would like to take this opportunity to thank key individuals who have contributed their knowledge, photographs, and time to the creation of this book. They have shown much hospitality and kindness to a perfect stranger. My sincere appreciation is extended to the following: Olivia Ferrante, Mickey Casoli, MaryAnn Maguire, Donald Craig, Lucy Patti, Ed Nazzaro, Peter McCauley, and Joe James. Thanks also to the following RSCHP members: Leonard Piazza, president; Lorraine Zolla, secretary; Catherine Kelly, vice president; Olga Doherty, treasurer; Jessica Capidilupo, correspondence secretary; Anne Marie Cella, curator; and executive board members Ann Fedele, Elsie Palermo, Rose Napolitano, Camille Albano, Marilyn Leyden, Mary DiOlimpio, Mary Anne Moscone, Margaret Nazzaro, Marie Giacobbe, Nick Giacobbe, Bill Reede, Mickey Casoli, and Mary Jane Terenzi.

I would also like to thank my wife, Joanne, who not only typed this manuscript but also understood my devotion of any and all free time to this project. She is a treasure that has enriched my life beyond measure.

Lastly, I would like to thank my father, John Craig, for his enduring loyalty to the city of Revere and his refusal to live anywhere else. By his loyalty and the grace of God, I could not have been born or raised in a better place.

INTRODUCTION

This book is the outgrowth of a desire, expressed by many, to have the history of our city published for posterity. With the passing of time, people, places, and events are forgotten.

The first settlers of what would become known as Revere were American Indians who belonged to the Pawtucket tribe. Their leader, Nanepashemet, resided in Lynn. Prior to British colonization, the Pawtuckets were at war with another tribe, the Taratines. The war lasted several years, weakening and devastating both tribes.

The first European visitor to the area was Capt. John Smith, who explored the New England coastline and named the Charles River. In 1624, Samuel Maverick arrived at the Plymouth colony from England. Maverick and several others decided to head north and establish a new colony. Maverick became so taken by a hill overlooking Boston Harbor that he selected it as the site for his home. The former naval hospital on Admirals Hill now occupies the site. Samuel Maverick's homestead became the first fortified home in the Massachusetts Bay Colony.

When the Puritans began to settle Boston, they came in contact with the Pawtucket tribe. The settlers named the tribe the Rumney Marsh Indians and peacefully coexisted with them. Samuel Maverick was attacked by the American Indians only once, according to his journals. It is believed that the attacking American Indians were from the Saugus area and did not belong to the Pawtucket tribe.

Over time, Samuel Maverick became quite prosperous. By 1634, all of what is now known as Chelsea was owned by Maverick. Within a year, Maverick would sell off his land to Richard Bellingham. In 1637, the king of England established boundary lines throughout Winnisimmet and Rumney Marsh. He then divided the land into 21 parcels and allotted them to Boston's most prominent citizens. Although most of the landholders did not reside on the granted land, Sir Henry Vane did reside on his parcel. In 1636, shortly after arriving in America, he became the elected governor of the Massachusetts Bay Colony. His 200-acre parcel would later become known as the Fenno Farm. From the allotments arose three separate settlements: one at Pullen Point, one at Winnisimmet, and one at Rumney Marsh. These settlements fell under the jurisdiction of Boston.

In 1641, a road was established connecting the Winnisimmet ferry landing to Salem. This road was originally known as the Salem turnpike and was the first county road in North America. In 1664, Rumney Marsh became home to a brickyard. Located in a clay pit near Snake River, the brickyard was the first industry in the area.

By 1739, almost all of the land had been cultivated and was being used for farming. The original 21 allotments had been divided into small farms and a few large farms. Rumney Marsh, Winnisimmet, and Pullen Point were now set apart from Boston and established as the town of Chelsea. Rumney Marsh, the largest of the three settlements, was established as the town center.

On May 27, 1775, the Battle of Chelsea Creek took place. This was the first naval battle of the American Revolutionary War. The colonists emerged victorious, defeating the British navy. The town of Chelsea had its first census in 1765. There were a total of 462 inhabitants. Twenty-five years later, after the Revolutionary War, the community had gained only 10 people.

By 1833, the Winnisimmet Land and Ferry Company had purchased the ferry franchise and almost all the land in the lower part of Winnisimmet. The company laid out the land in house lots. As the lots sold, that section of town began to grow. By 1837, there were 954 inhabitants in the area, while the town center at Rumney Marsh had only 436 people. At a town meeting on August 12, 1839, a petition signed by 43 voters of the ferry district was read at the town meeting. The petition requested that the town vote in favor of setting the ferry district off as a separate town, citing the difficulty of getting to Rumney Marsh for church service and schooling. Those present at the meeting voted to postpone the subject indefinitely. Had the petition been granted, Rumney Marsh would have retained the name Chelsea and Winnisimmet would have taken some other name.

Due to further growth, another town separation was about to take place. In 1846, the town of North Chelsea was incorporated. Chelsea had 2,100 inhabitants to North Chelsea's 900. Six years later, in 1852, the town of Winthrop was set apart from North Chelsea. In 1871, the name of the town was changed to Revere in honor of Revolutionary War patriot Paul Revere.

From 1852 to 1871, Revere's population grew slowly. It was not until the building of the narrow-gauge railroad and the opening up of the land at Beachmont and Crescent Beach that Revere began to grow and develop.

Through the use of photographs and text, this book will paint a broad picture of life in Revere. We hope to transport the reader to a sweeter time, when a trip on the narrow-gauge railroad was a delightful adventure and the streets were more animated.

In writing this book, it has been challenging to sort out a vision of the place we all call home, since published accounts and personal memories rarely coincide. It is our wish that readers will benefit from our labor and be strengthened in their loyalty to Revere's past, present, and future.

One

THE BIRTH OF A CITY

Revere was primarily a farming community in the years leading up to the 20th century. This was soon to change, however, as Boston was becoming overcrowded. Land companies began to look to the open areas of suburban cities such as Revere to help alleviate the land shortage. From 1860 to 1890, the L. D. Griswold Land Company sold house lots in Revere. The company gave away a dish bearing its logo to anyone who bought a house lot.

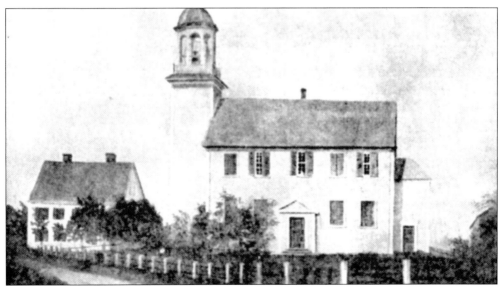

The Church of Christ, on Beach Street in Rumney Marsh, was dedicated in 1710, and until 1805 it was also used as a town meetinghouse. The church was originally supported by the town. When it was built, the church faced Beach Street; when it was remodeled in 1856, the building was turned about a quarter of the way to its present orientation. The main entrance and slave entrance were closed during the renovation. In 1887, the building was again renovated, and it was rededicated on April 19, 1888. This is the oldest church building in Suffolk County and is still being used at present as a mental health facility.

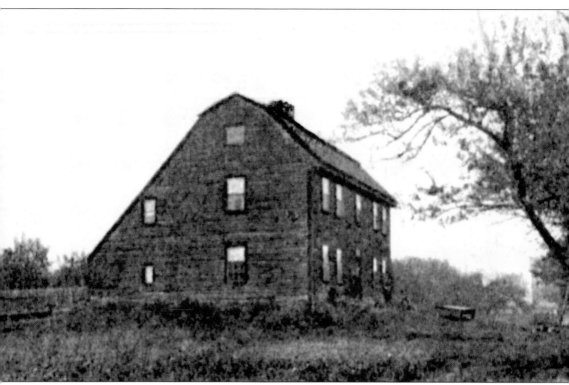

This fine home was built in the 1680s and stood on the Parkway near Mill Street. The home and land were originally owned by Boston merchant John Newgate, although he never resided on the property. It is widely believed that the first tenant was a man named Shrimpton, who began to purchase the property piecemeal in 1655. In 1713, Shrimpton's great-granddaughter Elizabeth inherited the property and married John Yeamans. The cellar of this home had a large cistern that captured rainwater from the roof. The cistern was probably built during the Revolutionary War in case of a siege. The home was invaded by British troops during a foraging expedition; the marks of British rifle butts could be seen on the living room floor. Up until the time the home was demolished c. 1904, it was known as the Newgate-Yeaman house.

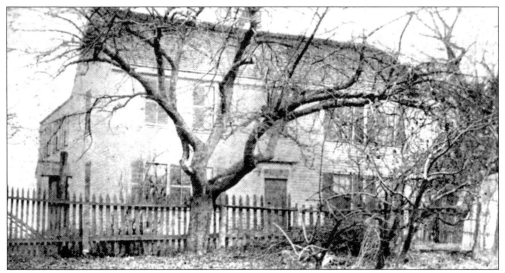

This stately home, built by Elisha Tuttle in 1690, was known as the Tewksbury Smith house and was located on School Street. Approximately 60 years later, the new owner of the property, a man named Hawke, opened a tavern in the home. Rev. Phillip Payson gathered a group of men at the tavern and headed to Lexington in April 1775. The men had a skirmish with British soldiers near Arlington. Payson's men defeated the British, stole their supplies, and took the surviving soldiers hostage. During the battle of Bunker Hill, men from Vermont and New Hampshire utilized the building as a safe house. The building is currently located at 22 School Street. In 2001, three-quarters of the home was torn down. All that remains of the original farmhouse is the front façade.

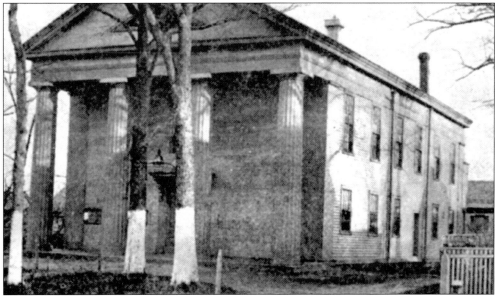

This is a photograph of the old town hall, built in 1835 on the site of the present city hall. The land was acquired from John Wright for the sum of $150 for a third of an acre. A town committee appropriated $3,000 for the purchase of the land and to erect the building. Once completed, the total cost was a staggering $3,063.03. The committee apologized to the town for exceeding the cost by $63.03. An addition to the building was erected in 1897 at a cost of $2,500.

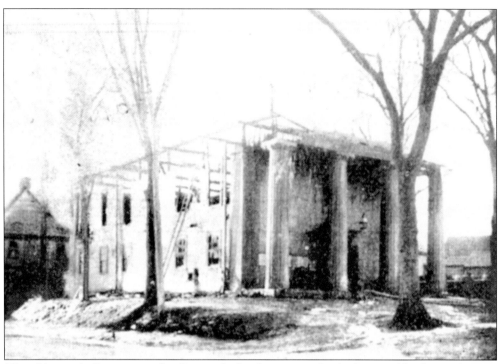

The old town hall was in use for 62 years before being completely destroyed by fire on January 19, 1897. The fire also badly damaged the town library, which was housed in a room of the old town hall.

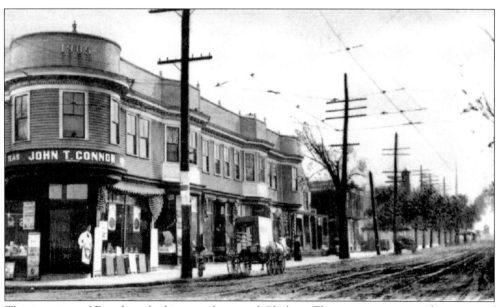

This is a view of Broadway looking south toward Chelsea. The grocery store on the corner of Broadway and Central Avenue has been replaced by the Citizens Bank building. Notice that Broadway was still a dirt road in the early part of the 20th century.

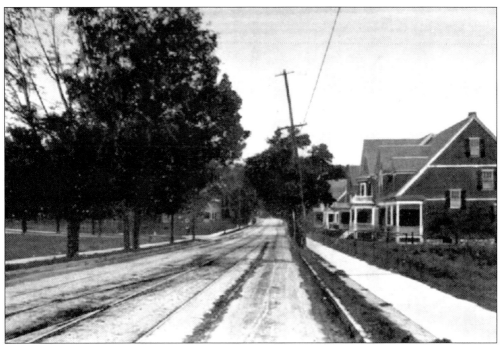

Almost unrecognizable is this view of Revere Street looking east from Broadway. At the time of this photograph, even Broadway was still predominately orchards and farmland.

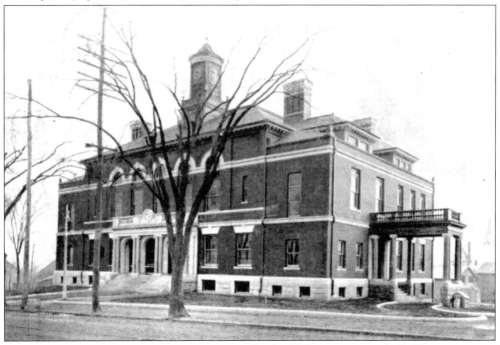

On February 8, 1897, a committee was appointed to build the present city hall. The cornerstone was laid on October 9, 1897, and Sen. Henry Cabot Lodge delivered the oration. The building was dedicated on January 11, 1899, and Lemuel K. Washburn delivered the oration. The total cost for the new city hall was $120,000.

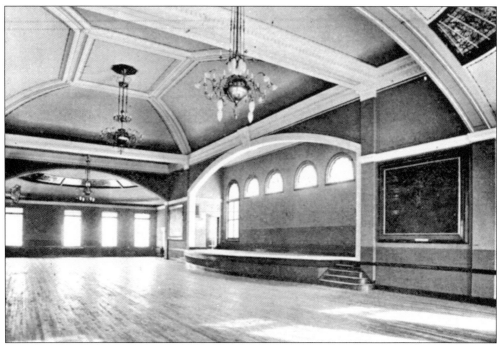

This is a view of the ballroom located on the second floor of city hall. When it was built, it was heralded for having the best acoustics in Massachusetts. Over the years, the ballroom has been used for many events, from the May Ball to high school dances. On May 8, 1999, the city hall was rededicated, and an evening cotillion was held in the ballroom to celebrate the 100th anniversary of the building. The ballroom has been modified over the years to accommodate the growing needs of the city government.

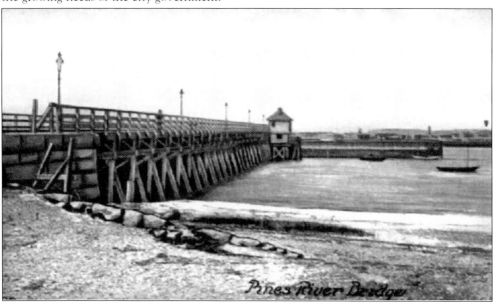

This is a view of the original bridge that connected the Point of Pines to Lynn. It was built in 1906 to serve as a direct route to the North Shore. The bridge caught fire in 1921 and was rebuilt in 13 days. It was replaced by the General Edwards Bridge in 1933.

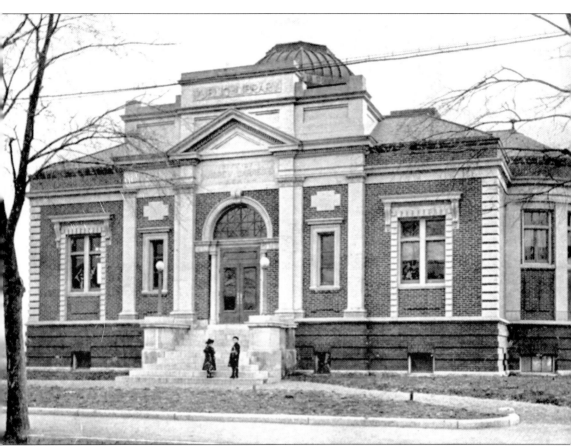

The area's first library, known as the Chelsea Social Library, was created between 1825 and 1830 by Rev. Joseph Tuckerman, pastor of the Unitarian Church, and the Cary family of Chelsea. Subscribers bought shares for $1, which allowed them to check out books. In 1840, the library moved into a room at the town hall; by the 1860s, the library had closed. In 1872, Rev. Louis Aldrich attempted to establish a reading room in the old engine house, but within a few weeks, the doors were closed. In 1880, the town appropriated $500 to establish a library once again, this time in the old town hall. When the building was damaged by fire in 1897, the library was moved to the Sherman-Hannah Block on Broadway until the new town hall was completed, at which time it was moved into the basement. The present library was built in 1903 with a gift from Andrew Carnegie.

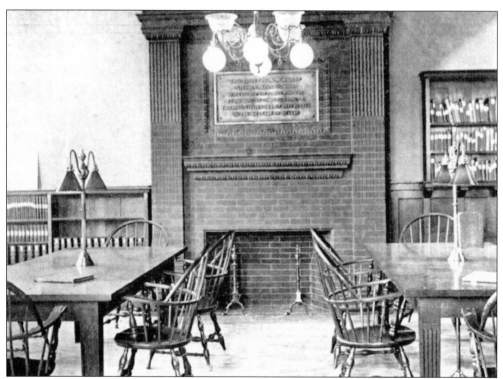

Pictured in this 1913 photograph is one of the reading rooms in the present library, looking very much the same as it does today. Andrew Carnegie donated $20,000 for the construction of the building, with the stipulation that the city would budget $2,000 annually for the library. The Revere Woman's Club, formed in 1894, raised money to furnish the rooms of the new library. The club still contributes greatly to the library.

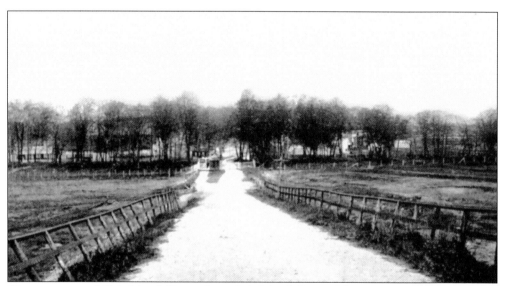

This is a view of Oak Island Grove from Oak Island Street. This entire area was privately owned. Today the area is a residential community.

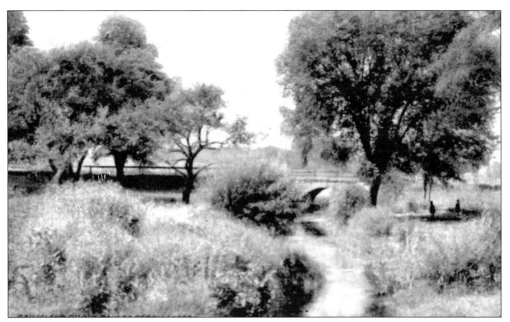

This photograph was taken at Oak Island Grove. Although the land was privately owned, it was used for picnicking and dancing for many years before homes were built.

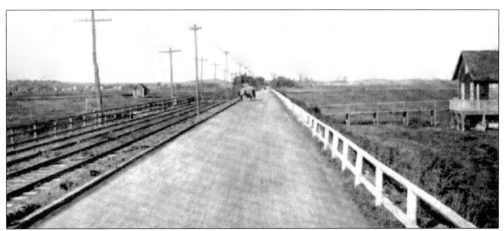

As seen in this view of the Lynn Marsh Road, this desolate stretch of roadway has not changed much in the last 100 years. Notice the farmhouse on the right.

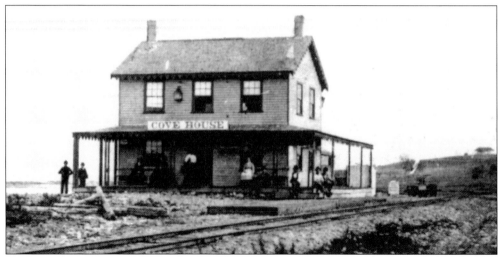

This is a view of the Cove House, which was located on the beach in the vicinity of Elliot Circle. The structure was erected in 1868; it was totally destroyed by fire in 1881. The railroad tracks alongside the building were utilized by the narrow-gauge railroad. Notice Beachmont hill in the background.

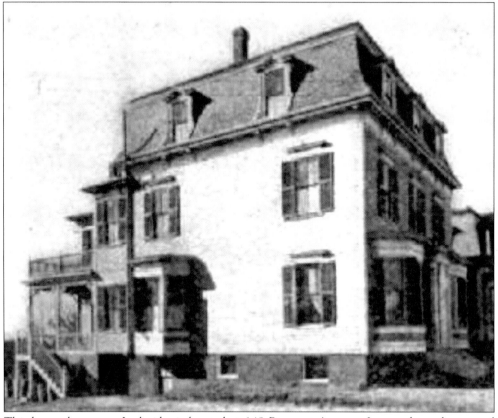

This home, known as Ingleside, is located at 148 Prospect Avenue. It served as a home and school for girls. By the 1940s, the school had closed, and the building was transformed into a boardinghouse.

The first form of police in Rumney Marsh came in the form of a tithing man. The highlight of his duties was to ensure that all citizens attended Sunday service. The position remained until 1837. When Rumney Marsh became North Chelsea, constables were hired every March. In 1872, appropriations were made to establish a full-time police department. The first police station was located in a converted engine house on Pleasant Street. Prior to 1873, the constables utilized two cells over an old hearse house. The police station was moved to Hyde Street in 1909; it was converted to a dwelling when the present station was built. This building was built at a cost of $22,200. Originally, the officers wore high helmets similar to those of the British bobbies. In 1913, they switched to modern police caps.

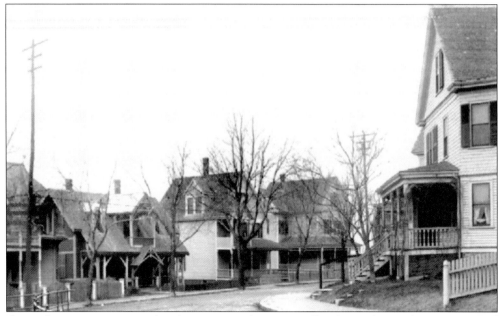

Once the narrow-gauge railroad was up and running, Beachmont's population increased rapidly. This is evidenced by these splendid homes on Bradstreet Avenue. In 1872, the Boston Land Company purchased 70 acres of land in Beachmont. People moving into this area made up the principal growth of the town from 1871 to 1881.

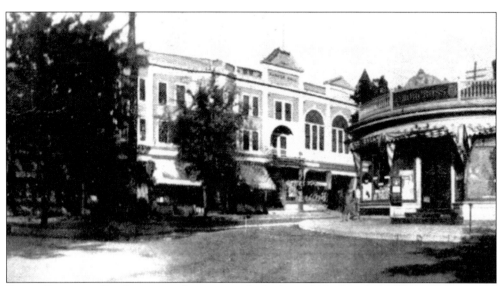

Depot Square in Beachmont is shown as it looked c. 1903. On the right is the Norcross drugstore. To the left is the Bellows Block, built in 1894. The second floor was Parker Hall, which was used for town meetings when the old town hall burned. The building was totally destroyed by fire in 1960.

Pictured here is the Broadbine family of Beachmont. Their homestead was on the northerly end of Washburn Avenue, across from the present site of the MBTA parking lot.

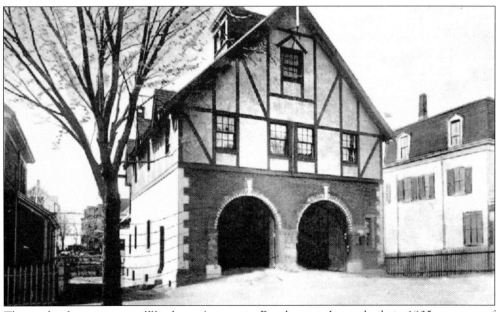

This is the fire station on Winthrop Avenue in Beachmont. It was built in 1905 at a cost of $10,500. At present, the fire station remains open.

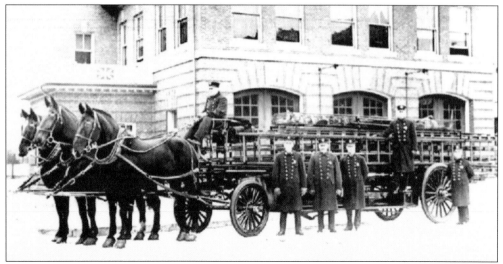

In 1885, the Revere Fire Department was established as a permanent fixture in the city. The first fire station was built that same year and was located on the corner of Park Avenue and Broadway. A new station was built in 1912 at a cost of $40,000 and was named the Central Fire Station. Pictured here in front of the Central Fire Station are the men who worked the hook and ladder.

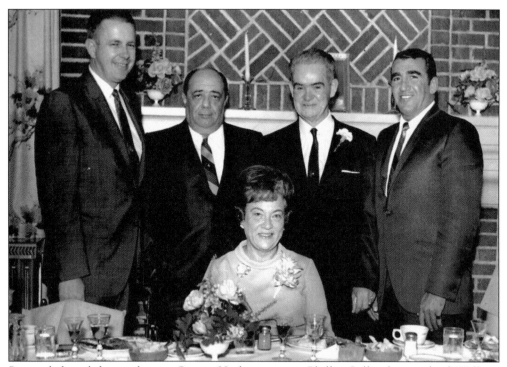

Pictured, from left to right, are George Hurley, captain; Phillip Gallo, deputy chief; William Gannon, chief, and his wife, Julie Gannon; and Mickey Casoli, detective of vice and narcotics. This photograph was taken when Captain Hurley and Detective Casoli were named policemen of the year in 1968. William and Julie Gannon are the parents of Revere police captain William Gannon. (Courtesy Mickey Casoli.)

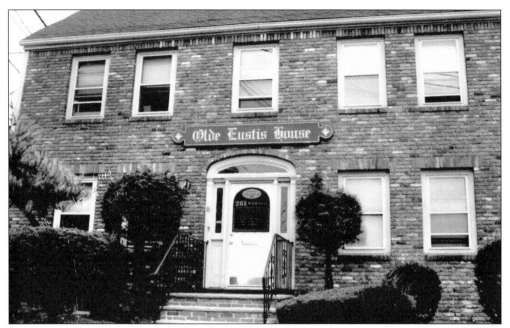

William Eustis built this home in 1805. It is located at the corner of Beach Street and Cary Avenue. In November 1812, Eustis sold a strip of land in front of his home to the town for a road. The home has been converted into professional offices.

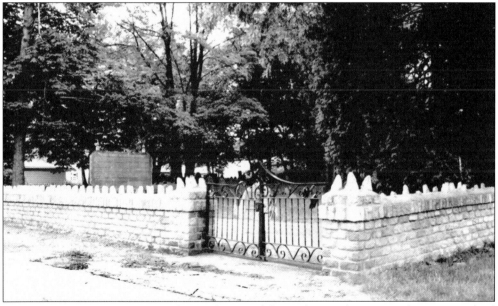

Pictured here is the Rumney Marsh Burial Ground, located on Butler Street. The cemetery land originally belonged Lt. John Hasey. The first person to be interred here was the wife of Capt. John Smith of the Ferry Farm in 1634. In 1748, the cemetery was given to the town by the will of Joshua Cheever, the son of Rev. Thomas Cheever. Some of the prominent citizens buried here include Dean Winthrop, Rev. Thomas Cheever, Capt. Samuel Sprague, Dea. John Sale, and Joseph Tewksbury. Historian Jeff Pearlman has lectured extensively on this landmark and has conducted tours here.

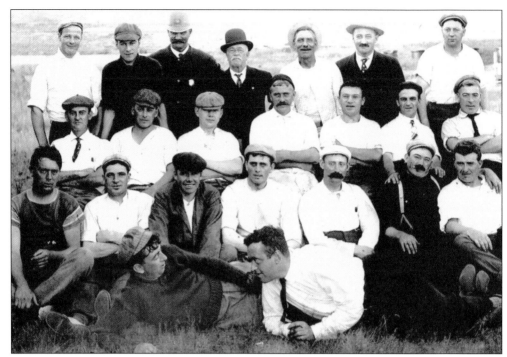

These lively gentlemen are members of the Revere Yacht Club. The photograph was taken during their annual outing in 1908.

A widely held misconception has been that this home, located at 88 Beach Street, was the birthplace of author Horatio Alger Jr. A historical marker was placed on the dwelling in the 1970s heralding that information as fact. But Robert Forrey discovered a discrepancy in the records of the Suffolk County Registry of Deeds, revealing that the Alger family never lived in this home. The historical marker has since been removed by the owner of the property.

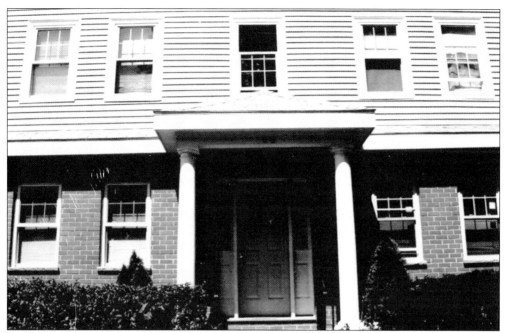

Robert Forrey claims that the home located at 66 Pleasant Street is the real Alger home. Rev. Horatio Alger Sr. had speculated heavily on land in Revere. He was caught financially short in the panic of 1837. In 1844, he was declared bankrupt. Perhaps this is why his son placed such a high regard on finances in his many novels.

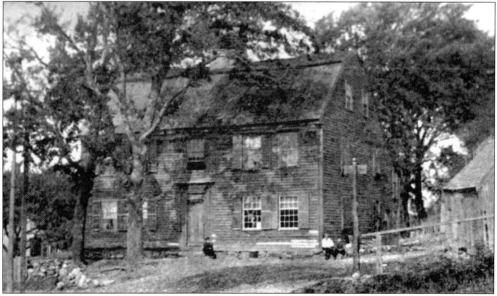

Originally, this simple saltbox home was located on Winthrop Avenue and was known as Cole's Farm, named after owner Samuel Cole, who never lived on the property. In 1654, William Hasey purchased the property. It was from this home that Deane Winthrop, son of Governor Winthrop, was buried. Nathaniel Hasey, descendant of William Hasey, sold the property to Joseph Green. During the Battle of Chelsea Creek, a contingent of Captain Sprague's men was posted around the farm in anticipation of British troops landing.

The Farnsworth house was built in 1869 and was located where the Immaculate Conception Church is today. The home was moved to its present location at Library Street in 1907, when the old high school was built.

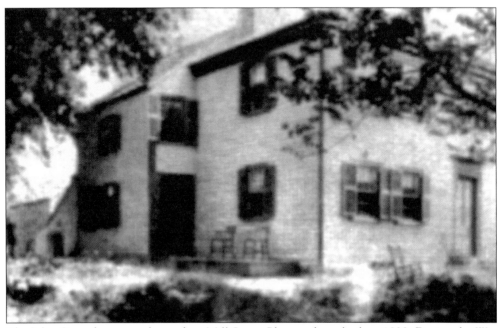

The John Green house was located on Mill Street Place and was built c. 1822. During the War of 1812, John Green witnessed the naval battle between the Chesapeake and the Shannon off the coast of Nahant from atop Young's Hill.

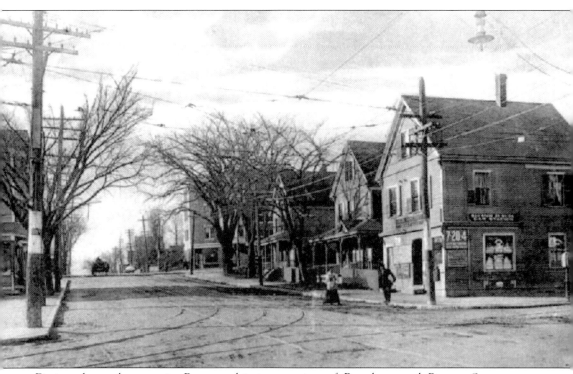

During the early years in Revere, this intersection of Broadway and Revere Street was considered the busiest area of the city. Times sure have changed since then.

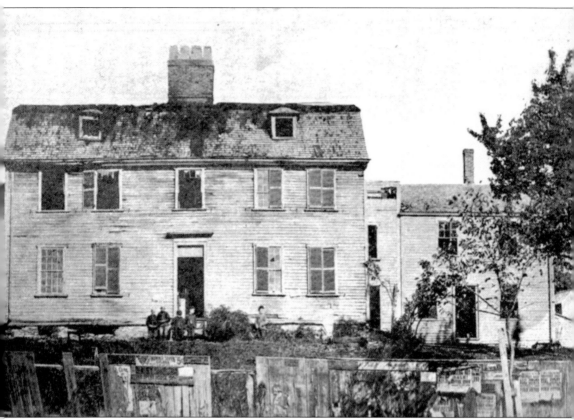

Originally built by Nicholas Parker in 1640, this building was also home to Rev. Thomas Cheever. He served as the minister of the Church of Christ and operated the first free school from this home on the corner of Prospect Avenue and Broadway. In January 1890, a fire partially destroyed the building; it was finally razed in 1904.

Two

TRANSPORTATION

One of the biggest reasons for Revere's transformation and growth was the advent of mechanized transportation. The city of Revere has seen the horse replaced by the steam locomotive and the trolley replaced by the automobile. Revere has been propelled forward by the different modes of transportation.

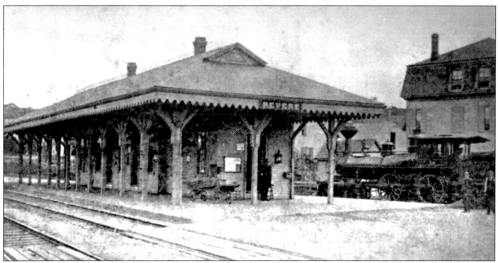

The first mechanized public transportation to come to Revere was the Eastern Railroad. On August 26, 1871, the Revere station was the site of a horrific train wreck in which 29 persons were killed and 57 injured. At the time the station was built, Winthrop Avenue was a grade crossing. In 1884, the line was taken over by the Boston and Maine. The last train stopped at the station on August 13, 1954, and made its final delivery of passengers and mail. The station has since been torn down.

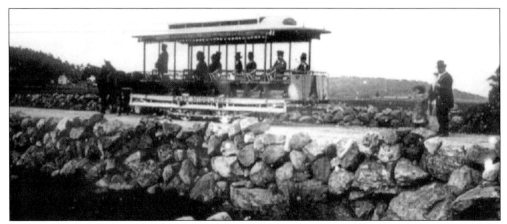

This rather archaic form of transportation was known as the Middlesex Horse Railroad. The line ran from Malden to Crescent Beach, traveling from Malden Street to Revere Street and turning around on Ocean Avenue. This 1887 photograph shows the first horsecar.

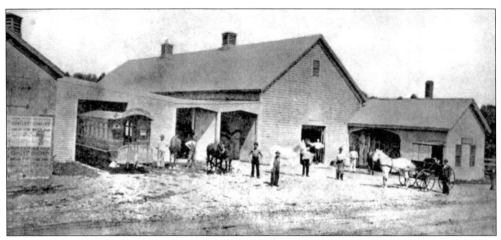

This is a view of the Lynn and Boston horsecar barns in 1887. Since Revere was halfway between Lynn and Boston, the horses were changed here.

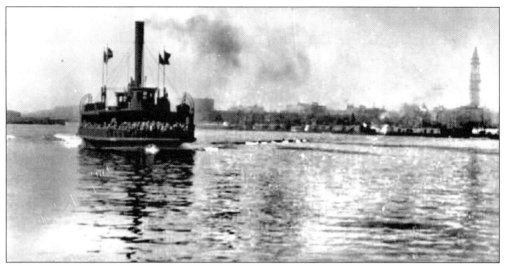

The Boston, Revere Beach and Lynn Railroad (affectionately known as the Narrow Gauge) was conceived as an enterprise to promote land speculation in East Boston and Revere. The company began service in 1875 with 3 locomotives, 11 cars, and 4 large ferryboats. The journey began from Rowe's Wharf aboard a ferryboat, which connected with trains at East Boston.

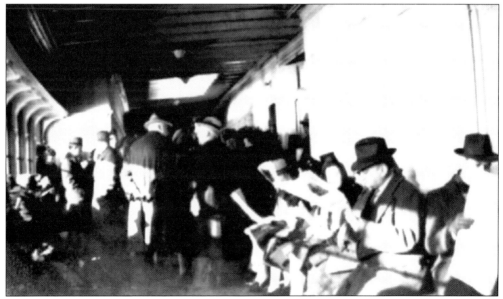

Here is a view of ferry passengers enjoying the ride across Boston Harbor. This photograph shows how roomy the ferries were.

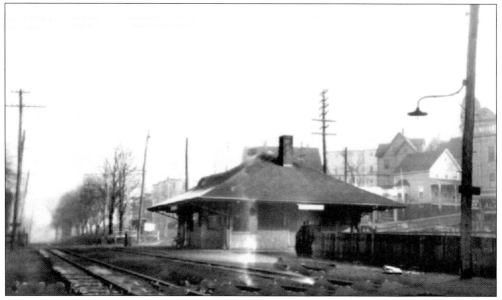

This is a view of Beachmont Station from Washburn Avenue, looking northeast. Beachmont Station remained a grade crossing until the Massachusetts Transportation Authority (MTA) took over the line.

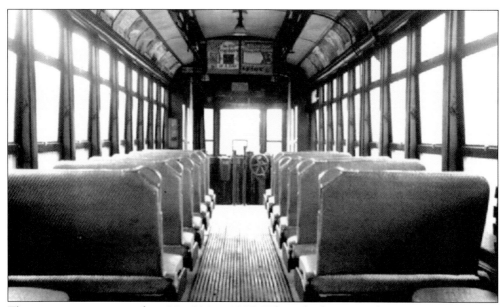

This is an interior view of car No. 201 in 1935. When the line ceased operations on January 27, 1940, the equipment was sold to Samuel Gordon, a Chelsea junk dealer, for $188,756. The cars were sold to rail lines around the country.

Seen in a view looking north, these tracks ran parallel to Ocean Avenue. On the left is the back of the Garfield Junior High School. This photograph was taken after the rail line was electrified in 1928.

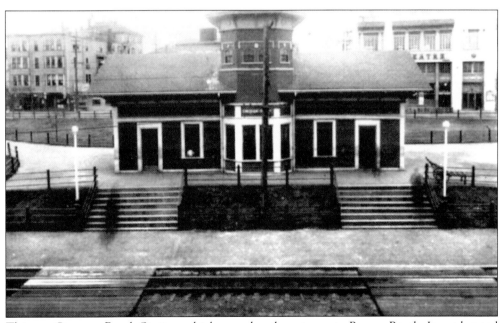

This was Crescent Beach Station, which served as the gateway to Revere Beach. It was located on the present site of the Revere Beach MBTA station. The building was a wonderful example of Victorian architecture.

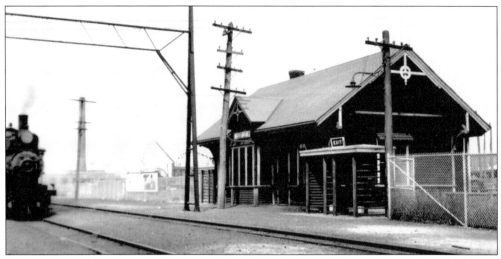

Here we see a locomotive pulling into Bath House Station. The station was located on the present site of the Wonderland MBTA station. The Cyclone roller coaster can be seen in the background.

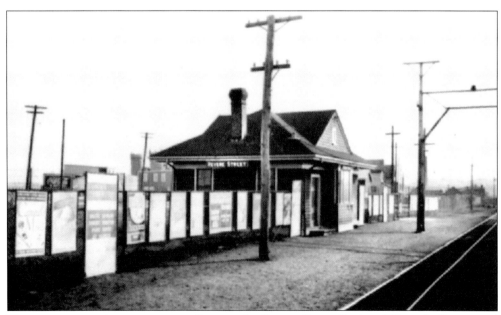

The next stop on the narrow-gauge line was the Revere Street Station. When the line ceased operation in 1940, this station was torn down.

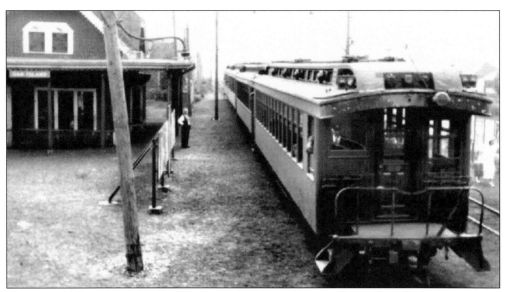

Shown in 1940 is the Oak Island Station, which was also torn down when the line closed.

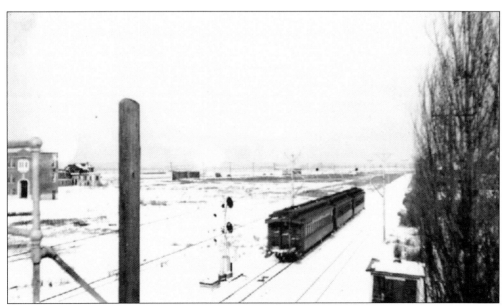

This train is approaching the Oak Island Station. The Carl Willard Mabie Oak Island School can be seen on the left. Notice how undeveloped this area was in 1940.

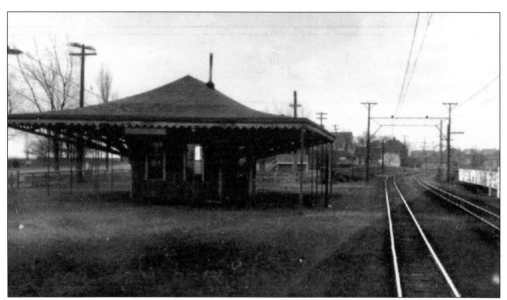

The Point of Pines Station was the last stop in Revere for the narrow-gauge line. When the line closed in 1940, it was an end of an era. Sixty-four years of service ceased due to the company filing bankruptcy. Upon reflection, the narrow-gauge railroad had succeeded for its original promoters. Revere's population had grown, and the beach had become a popular resort as well.

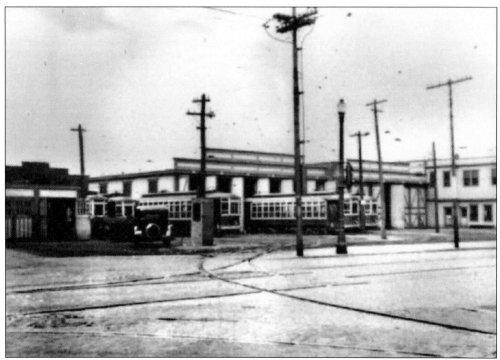

When the Boston Elevated Railway Company began rail service in Revere, the fare was set at 10¢ in an attempt to gain patrons from the narrow-gauge railroad. Pictured here is the carbarn that was located on Broadway. The trolley cars were stored and repaired in this facility. Walgreen's currently occupies this site.

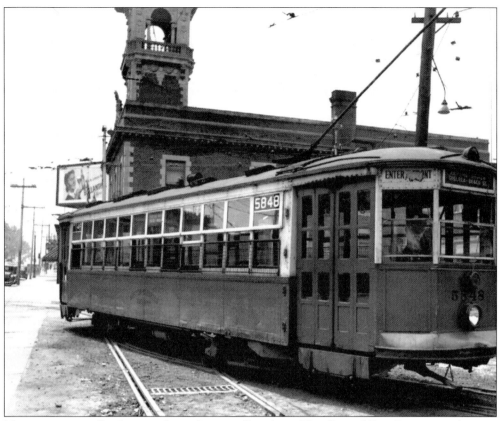

Here we see a trolley leaving the carbarn on Broadway. The Central Fire Station can be seen in the background.

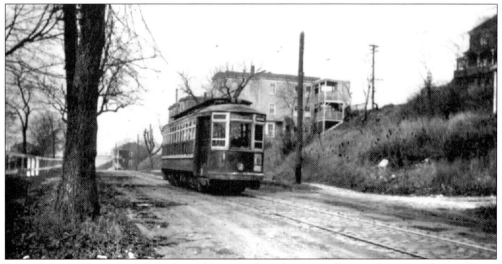

Part of the trolleys' appeal to the public was that they ran all over the city. This trolley is heading to Beachmont, traveling on Winthrop Avenue. Hillside Avenue can be seen on the right. Today, the hillside is overgrown with vegetation, and this section of Winthrop Avenue is a one-way street that has been renamed Revere Beach Parkway.

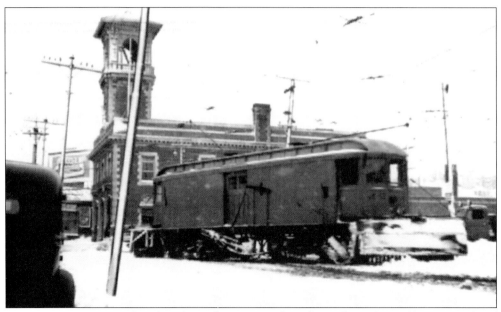

It is important to remember that the trolleys operated in all weather. This trolley was outfitted with a plow to ensure customer satisfaction even in a snowstorm.

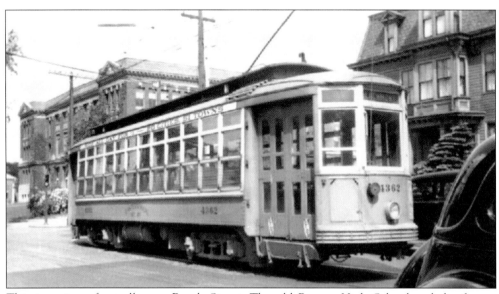

This is a view of a trolley on Beach Street. The old Revere High School and the former Immaculate Conception Convent can be seen in the background. The convent was located where the parking lot of the Immaculate Conception School is today.

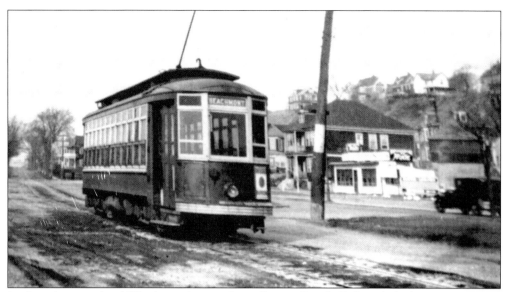

In this photograph of Winthrop Avenue (now Revere Beach Parkway), looking west toward Broadway, we see another product of the emerging transportation boom. To the right of this photograph is Emil's Gas Station, which was located on the corner of North Shore Road and Winthrop Avenue. There were originally three buildings on the corner that catered to motorists. They have been torn down and replaced by a self-service station and convenience store.

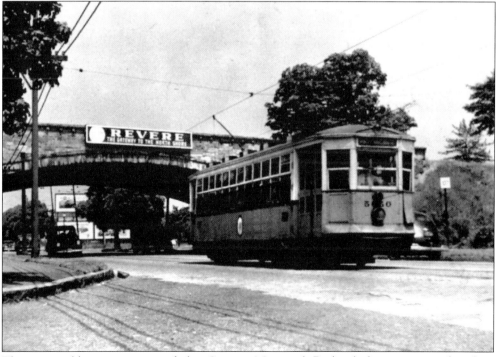

This is a seldom seen view of the Cassasa Memorial Bridge before it was widened to accommodate the increased traffic of Revere Beach Parkway. The bridge is named in honor of Andrew Cassasa, the first Italian mayor of Revere.

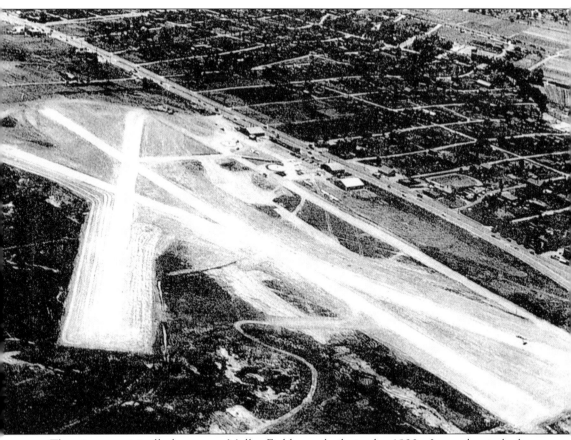

The airport, originally known as Muller Field, was built in the 1920s. It was located where Northgate Shopping Center is today. During World War II, the airport was closed for security reasons; however, the Ford plant in Somerville tested tanks and armored cars in the marshes near the airport. In 1946, Julius Goldman purchased the airport and opened Revere Airways. In 1947, the airport also began seaplane operations and blimp landings. In July of that same year, the Goodyear blimp landed here. By 1962, the airport was officially closed.

Three

SCHOOLS

The first school in the Revere area was established on January 24, 1709, in the home of Reverend Cheever, who was paid out of the town treasury. On May 17, 1749, the first schoolhouse was purchased by the town for 10 schillings. The building was located near Beach Street and Central Avenue. The Barry house, which stood on Broadway, was believed to be the former schoolhouse. In 1805, the schoolhouse was sold and moved, and a new brick school was built in its place. In 1838, Rev. Horatio Alger, chairman of the school committee, informed the town that the schoolhouse was inadequate, and a committee was established in March of that year to address the issue.

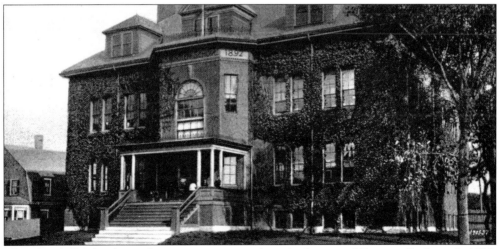

The Shurtleff School was the most controversial in the history of Revere. On June 4, 1838, land was acquired on School Street from John Pierce for $200. By February 1839, the children were occupying the school. The cost of the building was $9,269.85, not including the fence, bell, and benches. The school committee pulled the students from the building and refused to accept the new school due to its cost. By 1840, Dr. Shurtleff had sold the building to the town for $5,000 and made a gift of the balance. The original Shurtleff School was torn down in 1892 and a new building was erected.

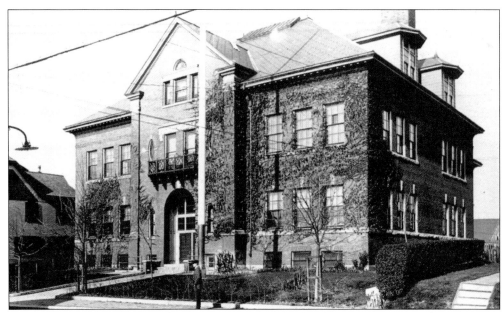

Originally known as the Bradstreet Avenue School, this building was erected in 1896. It contained eight rooms and an assembly hall. The total cost was $39,500, which was somewhat high, having been increased by the cost of litigation between the contractor and the town. This was the second school on the site. The first one was built in 1877 and was sold and moved to make room for the new school. Today the building has been converted to condominiums.

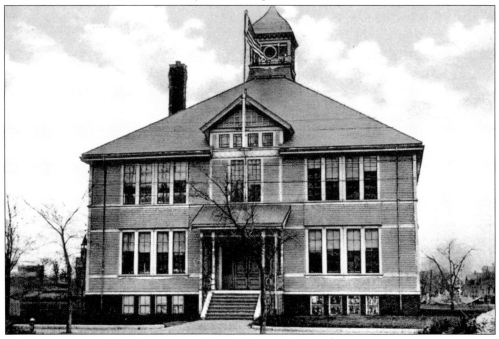

The Winthrop Avenue School was built in 1885 at a cost of $18,300. Originally, this was an eight-room wooden building. The top floor suffered a fire in 1903 and was never replaced. The building was later used for shop courses by the high school. Currently, it is being used by Revere Special Needs.

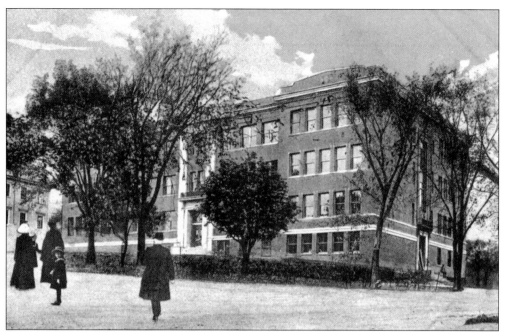

In 1879, the Malden Street School was built at a cost of $2,900. In 1911, the Lincoln School was erected on the same site. An addition was built in 1931. The building was completely destroyed by fire in 1963.

This is the second Lincoln School and the third school built on the site. The building was erected in 1967 and is still in use at present.

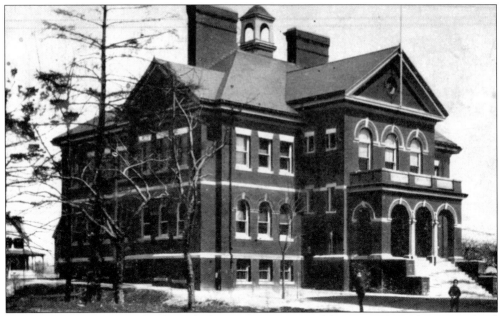

The Mountain Avenue School was built in 1898 at a cost of $49,000. The eight-room school was built in a fashion similar to that of other schools of the period. It has since been torn down, and the land has been sold off as house lots.

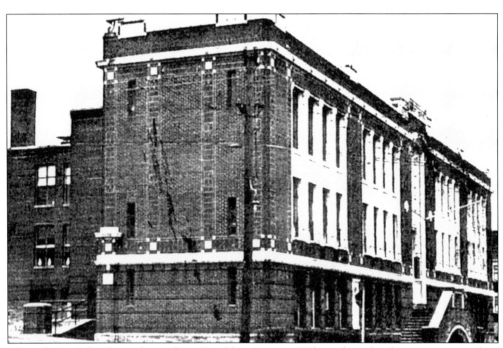

The Liberty School was located on Franklin Avenue. When the school was operational, it served the Shirley Avenue community as an elementary school. The school has since closed and been torn down. Townhomes now occupy the site.

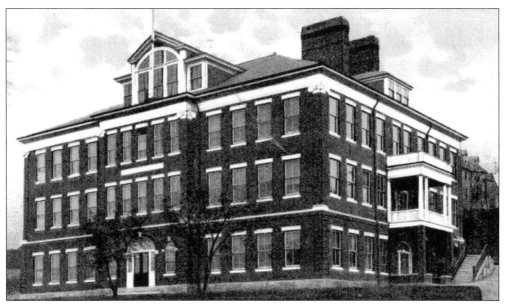

The Wolcott School was located on North Shore Road directly across from Wolcott Avenue. It was built in 1900 at a cost of $59,723. It contained 12 rooms and an assembly hall. The building suffered a fire and was torn down. Townhomes now occupy the site.

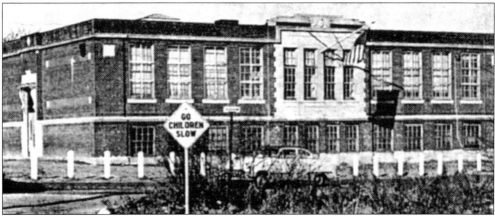

The Louis Pasteur School was located on Leverett Avenue. It was built in 1925 and was the third school in Beachmont. It has since been torn down, and a park now occupies the site.

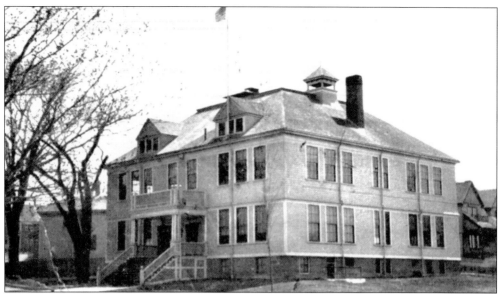

This school, originally known as the Crescent Avenue School, was built in 1890. It was later renamed the Julia Ward Howe School. The school has been renovated into apartments.

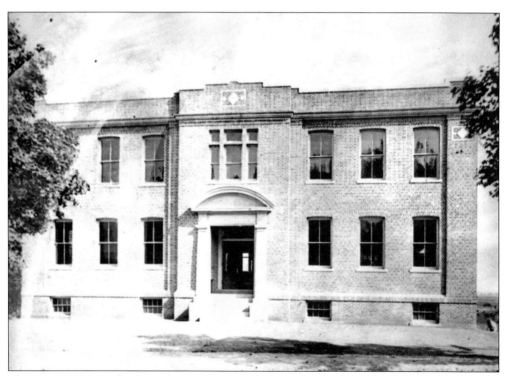

The Henry Waitt School was located on Salem Street. It was built in 1901 and was utilized by the children of North Revere. The school has since closed and been torn down. The city recently sold the land to a developer.

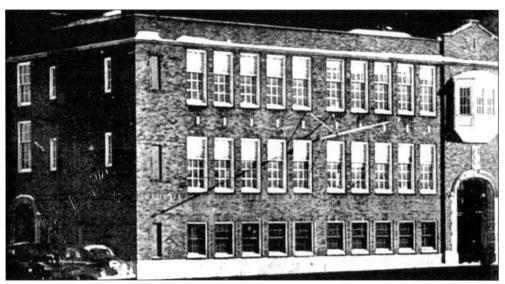

This school was built in 1923 and named the Carl Willard Mabie Oak Island School. It was located on Dashwood Street. The site is now a park and basketball court.

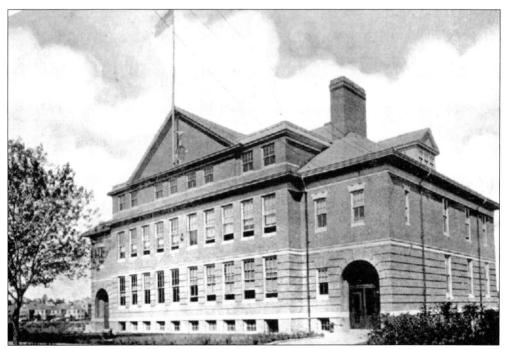

The McKinley School was built in 1904 at a cost of $45,000. This building is one of the few remaining schools from that time period and is still being used as a school.

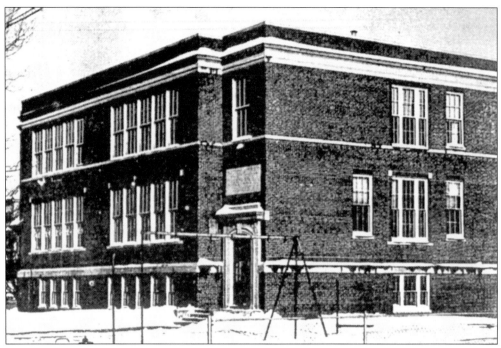

The Theodore Roosevelt School was built in 1924 and was located on Whittin Avenue. From 1946 to 1949, a junior high school was housed in the building along with the elementary school. The school has been razed, and homes now occupy the site.

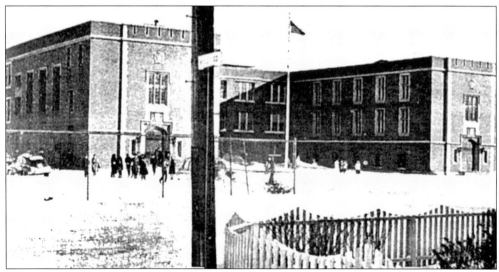

The Garfield Junior High School was built in 1925. It served as the junior high and later as an elementary school. The school closed in 1991, and the new Curtis Park now occupies the site.

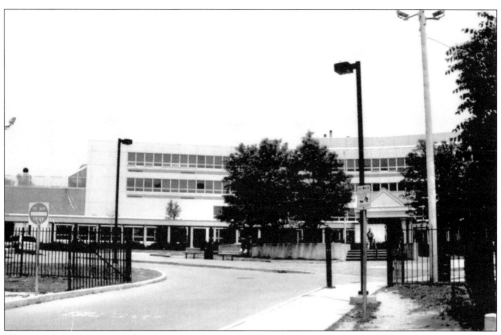

The Garfield Magnet School was built in 1991 on the former Curtis Park site. The school is much larger than its predecessor and features an indoor swimming pool.

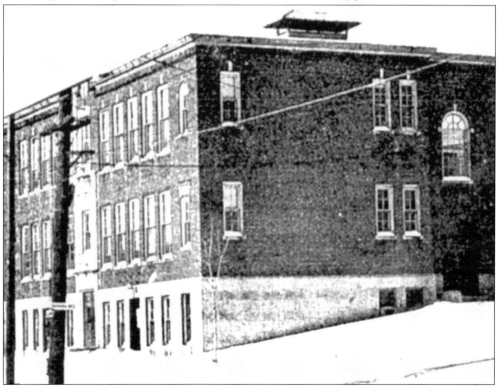

The Max Achenbach School was built in 1925 on Park Avenue. It has been torn down, and townhomes have been built on the site.

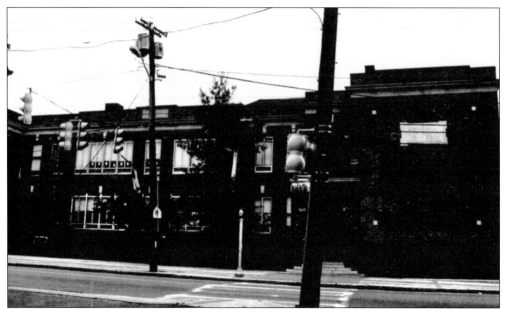

Built in 1903, the Paul Revere School has been utilized for over 100 years by Revere students. When the school was first built, it had only four rooms. Over the years, the building has undergone extensive growth and renovation. At present, discussions are under way to close the school and build a new school.

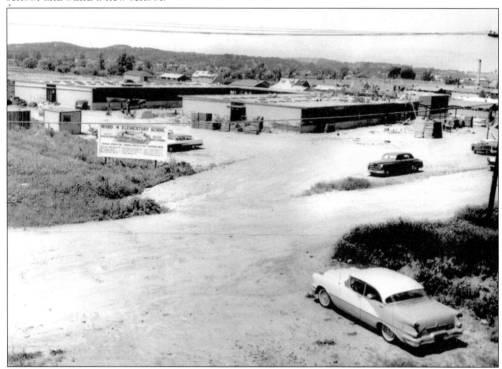

The Whelan School was built in 1957 to accommodate the growing population of west Revere. The school was erected on former farmland. Within the next few years, it will be torn down, and a new school will be built on the site.

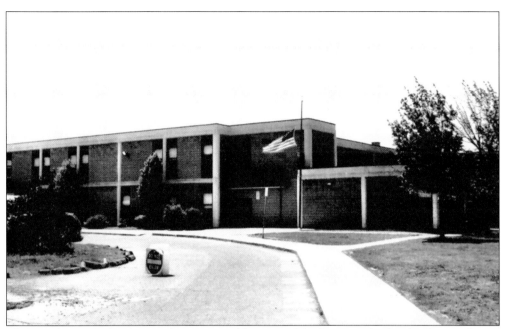

The Beachmont School opened in 1980 and has served as the junior high school since then.

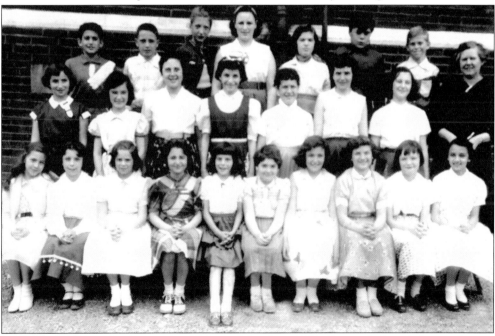

This is a fourth-grade class at the Wolcott School in 1954. Pictured, from left to right, are the following: (first row) Cathrine Smith, Patricia Votta, Marilyn Ginsberg, Beverly Moldoff, Kay Daley, Roberta Ginetsky, Paula Shultz, Susan Podolsky, Ann Kelly, and Linda Adelman; (second row) Sandra Grobman, Joanne Falzone, Cynthia Goldberg, Miriam Dubchansky, Paula Schultz, Eileen Moore, Phyllis Ansel, and teacher Miss Brenner; (third row) Edward Greenburg, Donald Donati, Athena Shepok, Ann Vigoda, Linda Gardner, Thomas Lombardi, and Joseph Miller.

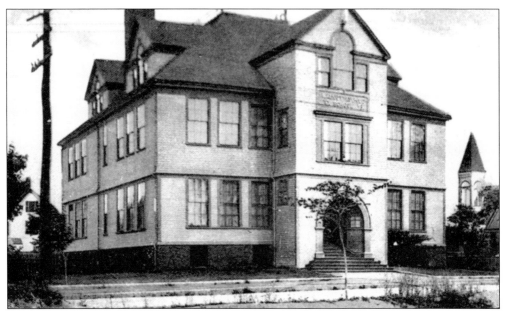

Facilities for a high school education have only been available to Revere students since 1895; prior to that date, students had to go to Chelsea, Malden, or Lynn for high school. In 1900, the prevailing school of thought for Revere was that a high school was an expensive luxury that would impose on the tax rate. On June 26, 1901, plans were announced that a high school would be located at the Walnut Avenue School. Mr. Morse was selected as principal at a salary of $1,000 a year. The school enrolled 50 freshmen. The first senior class graduated in 1905, and Theresa Julia Troyes became the first graduate due to an accident that jumbled the diplomas.

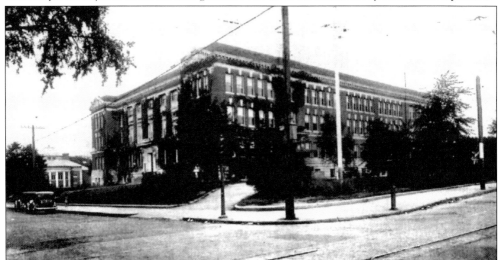

The second Revere High School was built in 1908 on the corner of Winthrop Avenue and Beach Street. Built by contractor Alan B. Carter at a total cost of $140,000, the school contained 14 rooms, 3 laboratories, an auditorium, and quarters for the school committee. In 1908, 315 students enrolled. In 1924, a cafeteria and gymnasium were added to the building. The school was closed in 1974 and was used as a storage facility until it was destroyed by fire. The Immaculate Conception Church now occupies the site. Former students may remember eating lunch at Bill's Spa, Pi Alley, and the Double E.

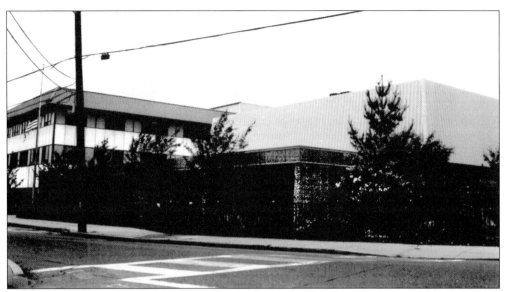

The present Revere High School, built in 1974, is located on School Street. The site was formerly occupied by Bowen's Garage and clay pits. The new high school was designed to be totally self-contained. Shop classes were to be housed at the high school, which also had a complete automotive shop. This was a major improvement; previously, students had to walk to the old Center School for shop class. Other improvements included the addition of parking facilities and athletic practice fields.

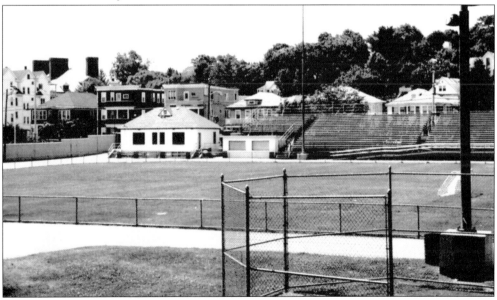

In March 1939, a debate erupted when Revere considered giving up its sports program due to the poor athletic facilities at Paul Revere Park. The conditions of the park forced the teams to play all their games away from home. The city council decided to utilize federal funds from the WPA, and on February 15, 1940, Mayor Gillis broke ground for the construction of a new stadium. The stadium consisted of temporary bleachers that could seat 1,000, a one-floor, three-room field house, a football gridiron, a baseball diamond, a cinder track, and lights, all at a cost of $60,000.

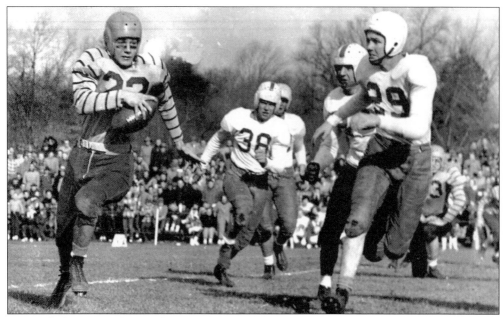

Originally known as the Beach City Boys, Revere High School's football team did not always play Winthrop on Thanksgiving. The team played Chelsea, then Winthrop, then Weymouth before returning to Winthrop. Here we see No. 29, John Craig, about to stop an advancing Weymouth runner in the 1951 Thanksgiving game. (Courtesy Craig family.)

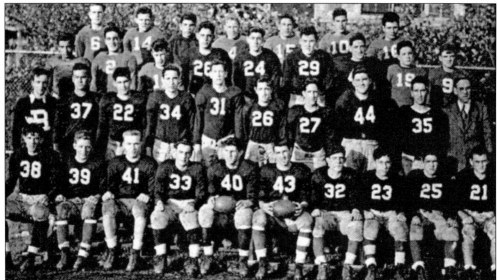

Members of the Revere High School football team of 1946, seen here from left to right, are the following: (first row) R. DiPiano, E. Haggerty, W. French, M. Langone, G. Sarno, M. Casoli, A. Sena, V. Palmisano, W. Lagorio, and I. Glazer; (second row) manager P. Mongiello, A. Andreottolla, V. Rapone, G. Bazar, G. Halper, N. Garafalo, A. Belmonte, J. Capidilupo, C. Shishmanian, and coach G. V. Kenneally; (third row) H. Frongillo, A. Russo, J. Buonadonna, H. Hodus, R. Laurano, S. Sweeney, R. Cerone, P. Mongiello, and J. McCarthy; (fourth row) J. Roche, A. Pagliarulo, A. Sasso, D. Stillman, V. Giarusso, J. Nardone, and J. Constanza. (Courtesy Revere High School.)

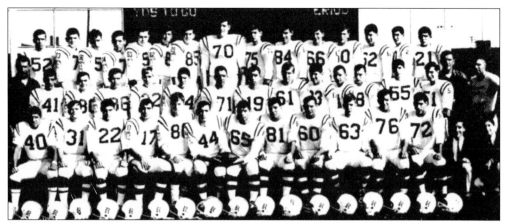

This motley-looking crew of individuals made up the 1965 Revere High football team. It was the only team in the school's history to have an undefeated football season. With a feat such as that, these athletes have truly made a place for themselves in the history of both the school and the city. (Courtesy Revere High School.)

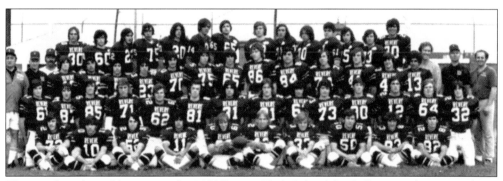

This rough-and-tumble group is the 1973 Revere High School football team. Players seen here, from left to right, are the following: (first row) Larry Hittinger, Jimi Simpson, Al Dioguarki, Jim Caramello, team captain Tom Guarino, team captain Dave Kelloway, Pete Lagorio, Mike Coughlin, Bob Marra, and Ed Manchur; (second row) Brian McGuiggan, Dan Flynn, Robert DeChristoforo, Mike DeGenova, Jim Love, Jim Drover, Joe Festa, Tony Belmonte, Louis DeMarco, Bob DiSalvo, Fred Glynn, Roy Santolucito, Mark Johnson, and Ted Ferrante; (third row) head coach Silvio Cella, assistant coach Robert Dolan, assistant coach James Agnetta, Don Goodwin, Pete Caccola, Mike Ciarlone, Phil DiLegro, George Foti, Vin Clucas, Steve Alvino, Tom Corbett, Mark Frammartino, John Luongo, Mike DeNofrio, Frank Mucci, Mark Bruzzese, assistant coach Alan Drover, assistant coach Henry Hooten, and assistant coach Thomas Russo; (fourth row) Dave Petrilli, Mike Misci, Mark Palladino, Michael Ferante, Mark Williamson, Bob O'Keefe, Bill Shute, Dan Sampson, Jim Bacon, Paul Tempesta, Steve Craven, Tom Flynn, Eddie Neal, and Joe DiPlatzi. (Courtesy Donald Craig.)

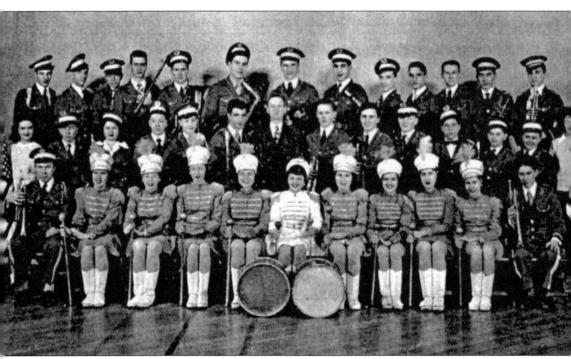

When we attend a high school event today, we hear a recorded soundtrack of music. Not too long ago, however, you would have heard live music performed by Revere students. Sadly, Revere High School no longer has a marching band. Seen here, from left to right, are the following: (first row) J. Garvin, C. Weaver, R. King, A. Moore, F. Curan, A. Fernandes, M. Giannino, P. Jacome, J. Di Modica, L. Tuffin, and A. Solombrino; (second row) A. Gatta, T. Collins Jr., I. Shane, R. Cataldo, R. Bagnulo, V. Frasca, Mr. Goss, R. Roman, D. Farthing, R. Westfall, J. Alviti, A. Pierni, E. Selant, and C. Garvin; (third row) J. La Cascia, A. Mannif, A. Fusco, E. Di Stasio, E. Roman, J. Aronson, M. Dontoff, D. Frammartino, G. Cataldo, A. Romano, P. Shannon, A. Williams, and J. Ranere. (Courtesy Revere High School.)

These students are a portion of the Revere High School graduating class of 1923. Notice the dress code that was in effect at that time. (Courtesy Craig family.)

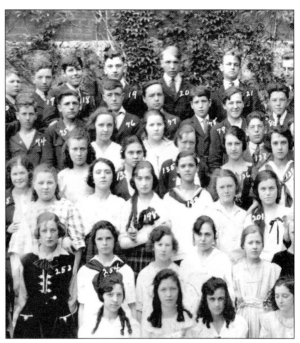

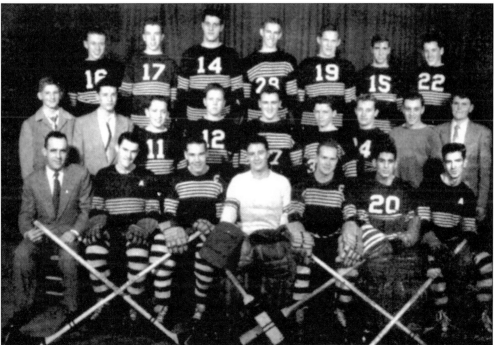

These are the members of the 1952 Revere High School hockey team. They are, from left to right, the following: (first row) coach G. Horner, K. Feyler, co-captain K. Ahearn, S. Faysal, co-captain W. MacDonald, R. Vito, and M. DeSimone; (second row) L. Hirshberg, P. Gesmundo, M. Avratin, D. Godfrey, P. Fanikos, R. Hudson, L. Kazmarak, G. Dunn, and W. Carney; (third row) R. Miles, A. MacCarthy, J. Erico, W. Myers, H. Lear, A. Vigliotti, and R. Ardini. (Courtesy Craig family.)

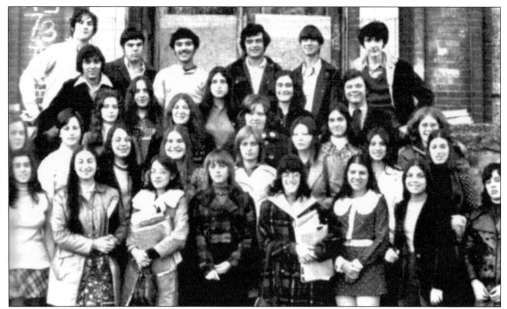

Pictured here are the members of the Revere High School Foreign Language Club in 1973. The members were Linda Allen, Selma Anderson, Susan Anderson, Janice Annese, Ann Cella, Henry Chorlian, Noreen Colannino, Kathy Collins, Cathy Costello, Herbert Cummings, Cheryl Decosta, Debbie Desantis, Donna Desantis, Ilene Dishler, Joyce Eydenberg, Karen Ficociello, Carol Furlong, Robin Gibbs, Donna Gibelli, Debbie Graf, Doreen Greenstein, Raffaellina Grieci, Mary Griffen, Joan Gruszecki, Gerry Iovana, Lois Kelley, Kenneth King, Steven LaMonica, Margie Levin, Iris Levine, Elaine Mattera, Joyce Mele, Albert Mogavero, Stephanie O'Neil, Linda Palmer, Maryann Penta, John Prochilo, Janice Rosenberg, Helaine Rothblatt, Caroline Ruccolo, Donna Sanechiaro, Mary Silver, Kevin Sinclair, Linda Stacey, Ellen Storlazzi, and John Verrengia. (Courtesy Donald Craig.)

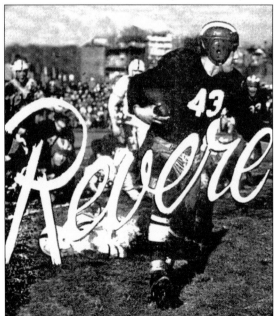

Revere High School has always encouraged student athletes to achieve the highest standards of sportsmanship. A quote by French author LaRochefoucauld perhaps summarizes what the Revere athletic department stands for: "Ability wins us the esteem of the true men; luck, that of the people." Here we see Revere High's greatest athlete of 1945, Mickey "Say No to Drugs" Casoli (No. 43) after he has just broken a tackle. (Courtesy Mickey Casoli.)

The Immaculate Conception School is located on the corner of Winthrop Avenue and Beach Street. It opened on September 9, 1913, with four grades and four Sisters of St. Joseph as teachers. The initial enrollment was 230 students, and a grade was added each year until the expansion of eight grades was completed. In 1921, a senior high school was added. The high school was closed in 1973, and the elementary school was expanded. Father Brennan Hall was erected in 1948. The school continues to provide an education to the Catholic community of Revere.

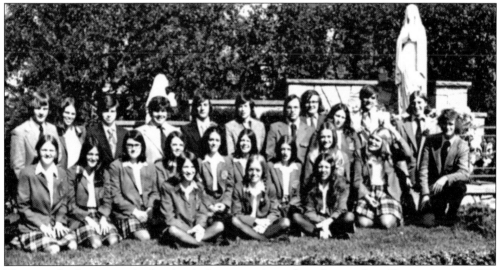

This was the last senior high school class to graduate from Immaculate Conception in 1973. The graduates were Cynthia Anderson, Janice Benoit, John Dyer, Michael Haggerty, Paula Ciccola, Denise Cummingham, William MacDonald, Carol Ferrante, Arthur Januario, Rita Fletcher, Joanne Flynn, Michael Myers, Gerald McMahon, Debbie Garigan, Kathleen Horgan, Judy Johnson, Robert Rampleburg, Anne Leardo, Stanley Orluk, Ann MacDonald, Mary Ann Maguire, Timothy Staub, Kathleen Marden, Anne Murphy, Daniel Weeder, and Christine Paone. (Courtesy Mary Ann Maguire.)

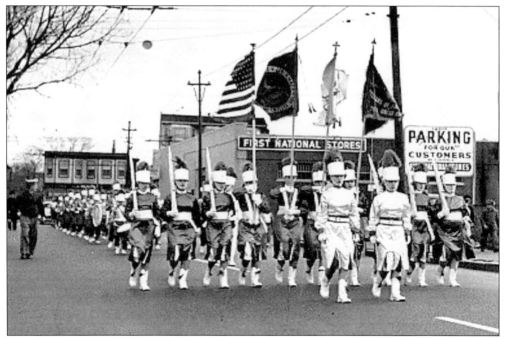

Here we see the Immaculate Conception Reveries Drum and Bugle Corps. This group was made up of parish youth and students. The corps was established in 1957 by John Brown. Within five short years, it was ranked as one of the top 10 corps on the East Coast. (Courtesy Immaculate Conception School.)

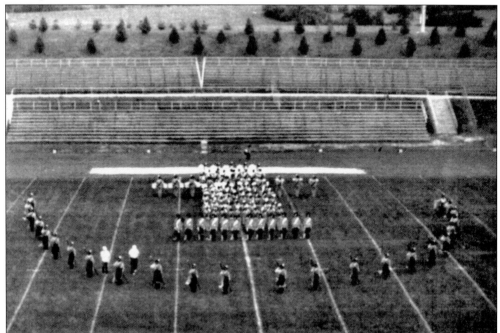

A great many Revere residents may remember the 27th Lancers Drum and Bugle Corps. This group of talented young men and women competed nationally and was ranked among the best in the country. Sadly, the group has been disbanded. (Courtesy Lucy Patti.)

Four

BUSINESSES

In the days before the prevalence of the supermarket, every residential neighborhood had its own local shops, usually anchored at the corner by a grocery store or drugstore. Food was the staple product, and next to the grocer there would also be a fruit and vegetable store. Dawn often broke with the clip-clop of the milkman making his rounds by horse cart. Stores-on-wheels also made regular rounds, saving housewives countless shopping trips.

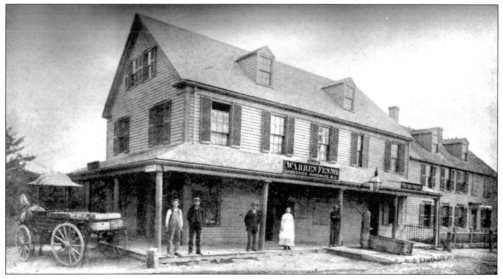

This store in Revere was located on the corner of Beach Street and Broadway. The building was erected in 1835 by John Fenno and his son Joseph. In 1849, William Fenno started a stage service from Revere to the ferry slip. He undertook three trips daily, with two extra trips during the summer season. All of these enterprises were operated from the building that now houses Reardon's Restaurant.

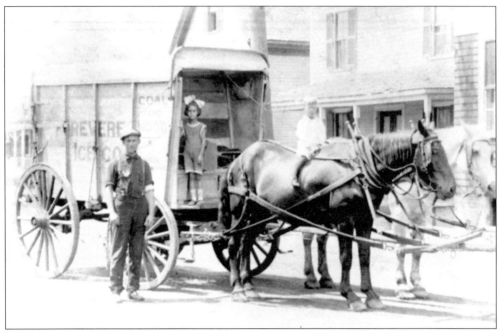

Long before Frigidaire became a household word, iceboxes kept perishables from spoiling. Salesmen for the Revere Ice Company, pictured here, would make their way along Revere streets selling 5¢ and 10¢ pieces of ice.

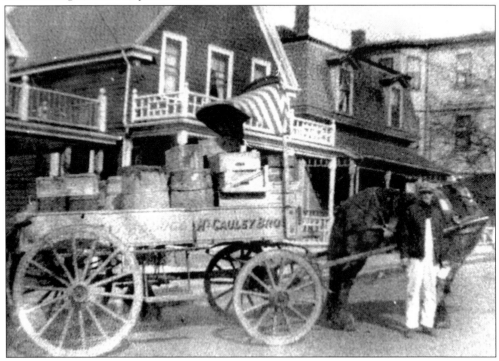

Peter McCauley Sr. is pictured here with his mobile fruit and vegetable store. Horse-drawn wagons were a common sight along Revere's thoroughfares well into the late 1940s due to the gasoline shortages of World War II.

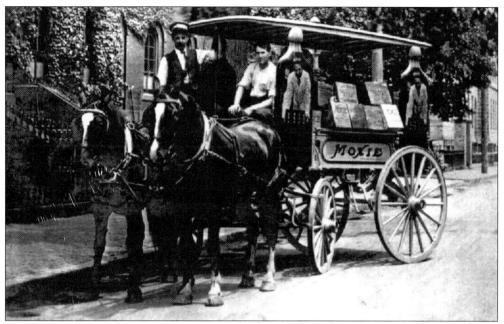

Horse-and-wagon combinations were used for everything from collecting garbage to selling ice cream. Here we see a Moxie delivery wagon making its rounds.

Pictured here is the Paone family. From left to right are the following: (front row) Sal, Theresa Paone Fedele, Cosmo, Maria, and Ann Paone Cole; (back row) Domenic, Joseph, Frank, Charles, and Ralph. Cosmo and Maria operated Paone's Market on Broadway, which became a treasured fixture of the community. (Courtesy Anne Fedele.)

In 1721, the inhabitants of Rumney Marsh petitioned the selectmen of Boston for the right to build a tidewater mill. The petition was granted, but there were so many restrictions attached that nothing was done until 1734, when Thomas Pratt built the mill at his own expense. The mill was destroyed by a disastrous fire in 1816. The town bought out Pratt's interest and built a new mill. In 1827, Henry Slade acquired the mill, which he used to grind snuff and corn until 1837, when Slade's sons conceived the idea of grinding spices. The building was placed on the National Register of Historic Places in 1972. The building is currently being refurbished and will house a restaurant.

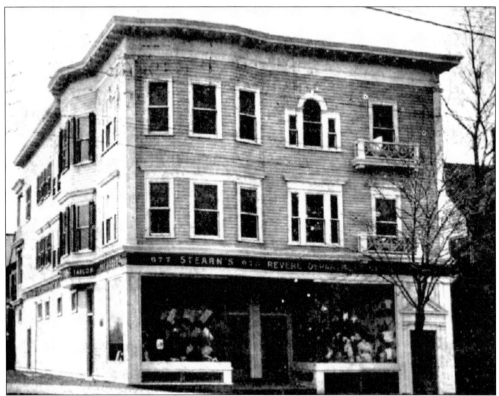

Here is a view of Stearn's department store, which was located on Beach Street. With stores like these located right in town, residents rarely had to go to Boston to make purchases. Local stores carried everything from suits and dresses to household appliances.

This photograph of Previte's market was taken from the Broadbine property in Beachmont during the late 1940s. Previte's served the entire Beachmont area for over 60 years before it was closed and sold to another proprietor in 2001. The market was a rarity for operating so long, staying in business even after the supermarkets sprang up in the city during the 1960s. It just proves that personal service and neighborhood cohesiveness will always prevail.

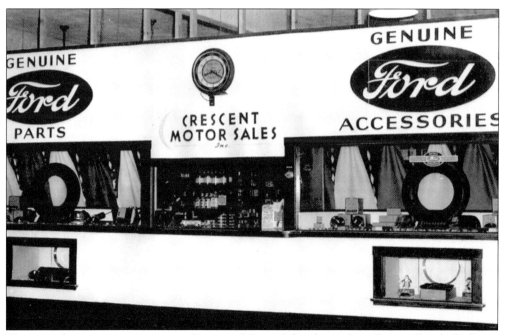

This was the auto parts center at Crescent Motor Sales, located on Revere Beach Parkway. Crescent Motor Sales was a full-service dealership that catered to the customer's every need. A storage facility occupies the site today.

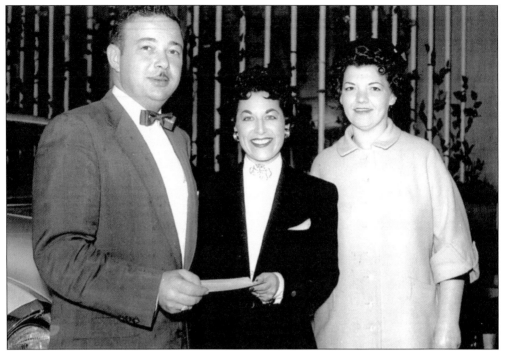

Revere businesses were an integral part of the community and were always willing to support charitable causes. Pictured here is David Freedland, manager of Bell Oldsmobile, presenting a check to Bernice Emerson, a worker for a campaign to benefit children with developmental disabilities, and Mrs. Marie, chairperson of the drive.

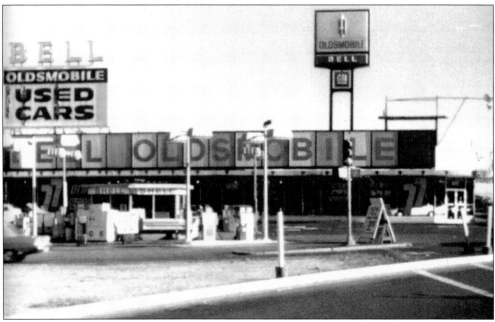

This is a view of Bell Oldsmobile in the late 1970s. The dealership was located in the building that is now occupied by Lappen's Auto Parts. Residents who grew up in this time period may remember going to the dealership with their fathers to see the new models for the year.

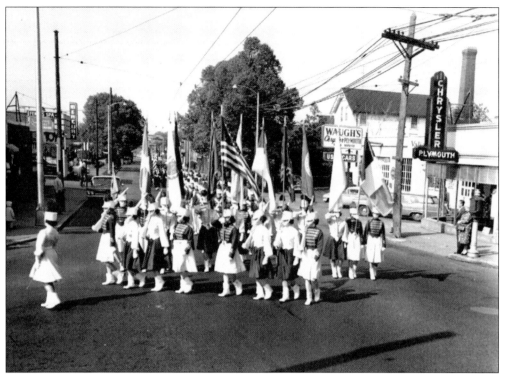

Here we see a parade on Broadway in 1956. On the right is Waugh's Chrysler and Plymouth dealership. Across the street was a Mercury dealership. Waugh's is still in business but is no longer a dealership.

This is a view of Shirley Avenue, looking west from Orr Square. Many may remember walking along Shirley Avenue on a Saturday afternoon during a day of shopping before this activity became a seven-day-a-week event.

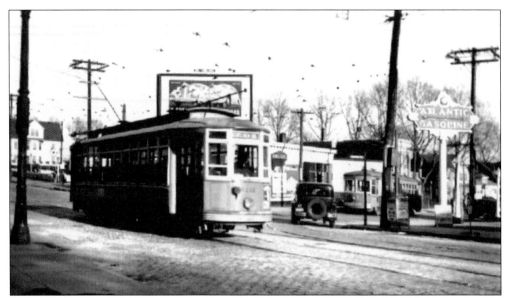

This is the corner of Broadway and Revere Street. An important part of the shopping day was taking the streetcar from your neighborhood to the shopping epicenters around Revere.

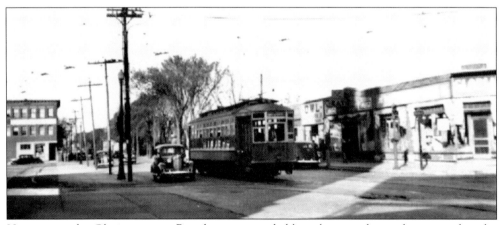

Here we see the Gloria store on Broadway surrounded by other merchants that catered to the various needs of the community. This block of stores has since been torn down and replaced with Broadway National Bank.

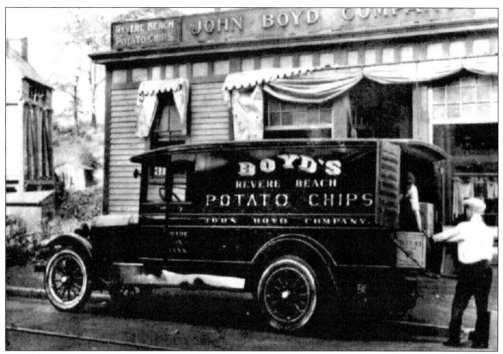

A delivery truck carrying Boyd's potato chips is being loaded in front of the company's store on Revere Beach.

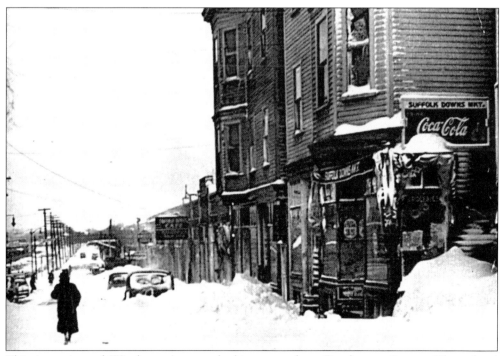

This is a view of Winthrop Avenue, looking west from Beachmont Square. These local businesses catered to the residents of Beachmont.

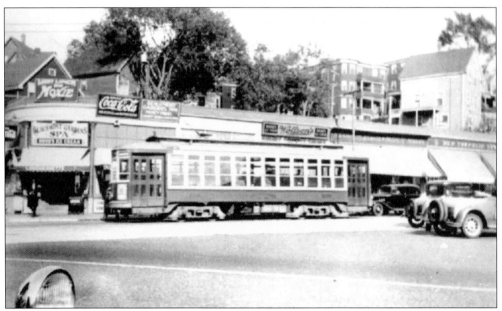

Here is a view of Bellows Block in Beachmont Square. Above the trolley is the sign to Wolfson's drugstore. Torretta's Bakery now occupies this site.

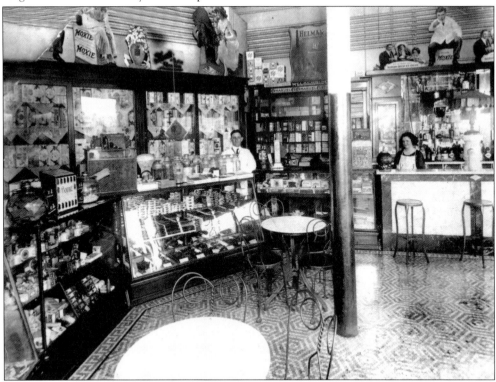

This is an interior view of Wolfson's. Drugstores like this did more than fill your prescription; they sold newspapers, candy, cigarettes, cigars, and more. Once you stepped inside, the aroma would envelop you. Today it is hard to find a real fountain, but at Wolfson's you could buy a Coke that was not premixed.

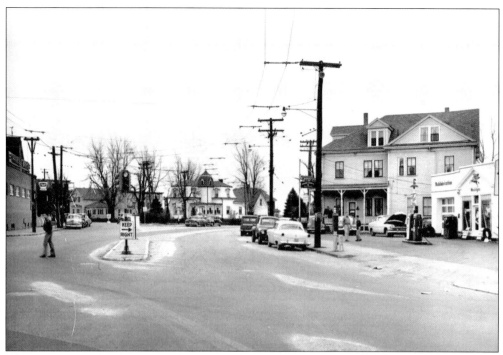

This is a view of Beachmont Square, looking south on Bennington Street. Dunkin' Donuts now occupies the site of the Mobil station.

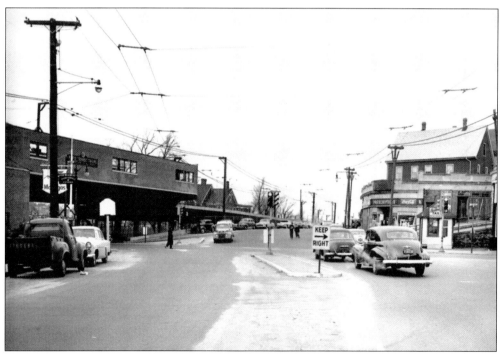

Here is another view of Beachmont Square, looking north. The original MTA station is on the left. It has since been remodeled. Depot Square has not changed much over the years.

This garage was located in Beachmont on the current site of the Beachmont School.

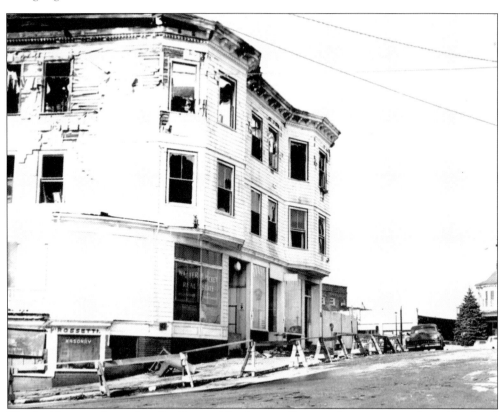

This building was located at Orr Square. The bottom floor was home to several neighborhood businesses. After being totally destroyed by fire, the building was razed and replaced by a brick office building.

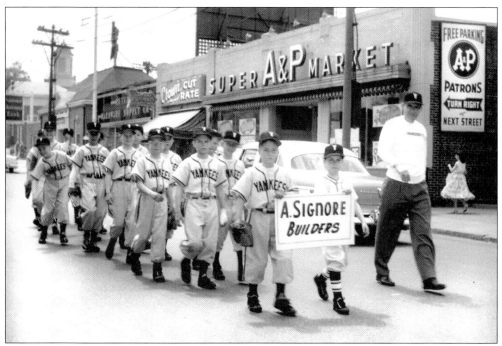

Here we see a team from Revere Little League marching in the opening-day parade in 1956. The Broadway A&P supermarket can be seen in the background.

This is another view of the Little League parade on Broadway in 1956. Here we can glimpse City Hall Pharmacy and the other shops along Broadway. In the background on the right is the Revere Theatre opposite city hall.

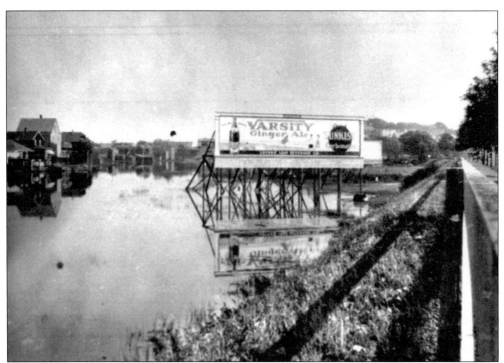

This is a seldom seen view of Sales Creek from the corner of North Shore Road and Winthrop Avenue. Most of this creek was filled in when Cerretani's supermarket was built. Shaw's now occupies the site.

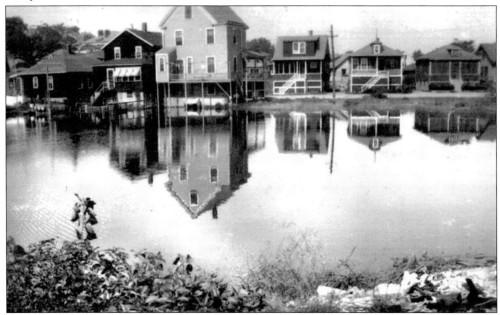

This is another view across the creek of the homes on Elliot Road. These homes were originally utilized as summer cottages. Families would rent these "bungalows" near the beach. Momma would continue the drudgery of housekeeping while looking forward to the evening sea breezes to make the summer tolerable. Over time, these dwellings were converted to all-season homes.

Simpson's Pier was located south of the remains of Holt's Pier at Roughan's Point. Many people may remember renting a boat for the day from Doris Simpson. The business was closed in the mid-1980s and has been torn down.

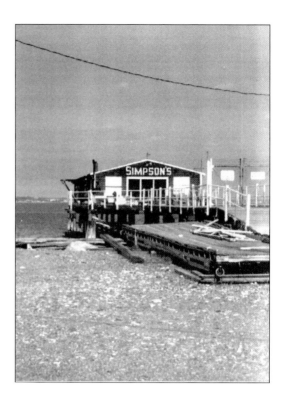

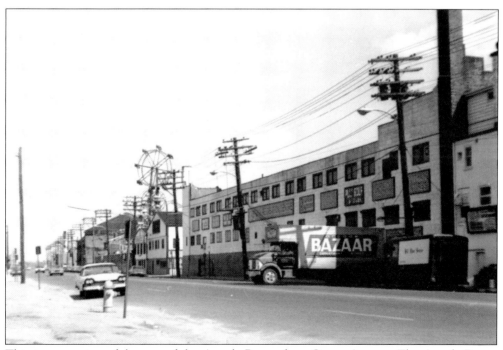

This is a rare view of the rear of the Arcade Bazaar from Ocean Avenue. The Arcade Bazaar had an eclectic assortment of clothing and knickknacks for sale and catered to a wide variety of tastes.

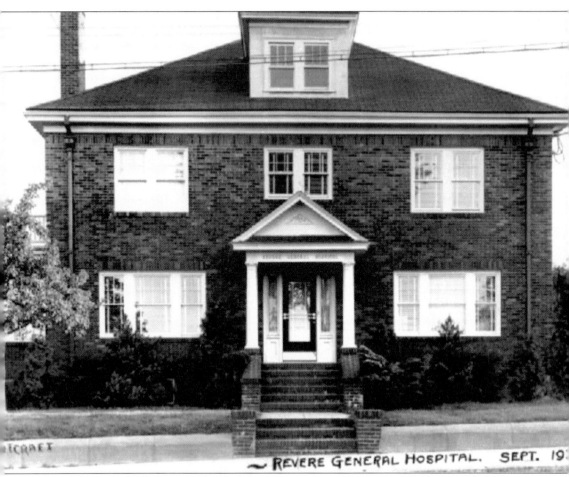

REVERE GENERAL HOSPITAL. SEPT. 19

This unassuming house was located at 204 Proctor Avenue. Originally named the Revere General Hospital, it was started by Dr. Francis Licata, who invested $70,000 to renovate the building into a 26-bed facility with a maximum capacity of 36 patients. The hospital had an x-ray room, a pharmacy, an emergency room complete with a driveway on Mountain Avenue, and a delivery room and operating room on the second floor. The hospital opened on September 25, 1939. In April 1948, the hospital was sold and renamed Revere Memorial Hospital in honor of Revere's veterans. Also in 1948, the hospital became a nonprofit organization. The site is now occupied by a nursing home.

Five

RECREATION

To most people, Memorial Day (or Decoration Day, as it used to be called) was the first day of summer. But to many Revere families, May 30 had a very different meaning; it was the day that Revere Beach was fully operational. The beach officially opened on Easter Sunday, but not all the amusements were open until Memorial Day. Revere Beach first became a pleasure resort in 1834 with the opening of a tavern in the Point of Pines, which catered to outdoorsmen who fished and hunted ducks around the salt marshes.

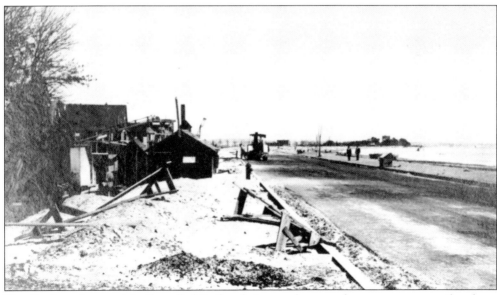

The Boulevard was originally called Railroad Avenue because the narrow-gauge railroad ran along the present location of the sidewalk. When the Metropolitan District Commission took control of the beach in 1896, Charles Eliott ordered the removal of all buildings along the waterfront and the relocation of the rail bed. His vision helped to create an uninterrupted view of the three-mile stretch of beach.

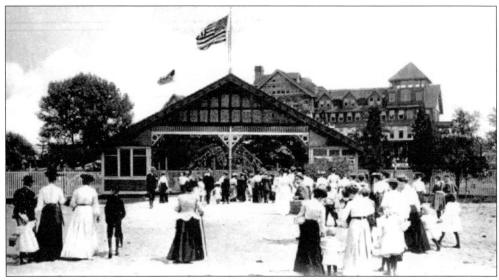

In 1881, Sen. Leverett Saltonstall and Sen. Henry Cabot Lodge Jr. formed a company with other prominent men. They purchased 200 acres of land at the Point of Pines and built a premier resort at a cost of $500,000. The resort had a hotel, restaurant, bandstand, racetrack, pier, bathhouse, and amusements. The Bull Moose party gathered to hear former president Theodore Roosevelt speak at the resort in 1912. The hotel closed in 1913 and was torn down in 1914. An airport utilized a portion of the property for a short time in the 1920s, and the racetrack was used for auto racing until 1933.

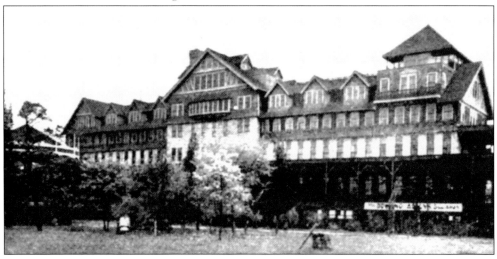

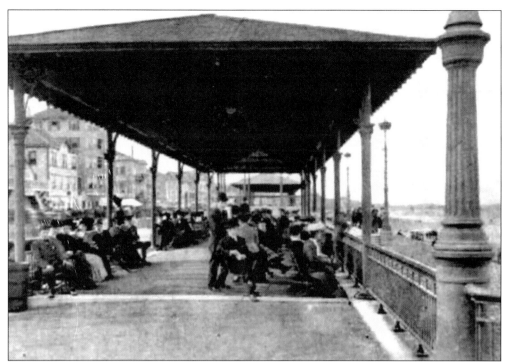

Here we see a crowd of well-dressed visitors relaxing in one of the many pavilions that overlooks the beach. It is important to remember that up until the mid-1960s, men and women dressed up when they came to the beach. The only time the people were not in dress clothes was when they were swimming, and even then the bathing suits were modest.

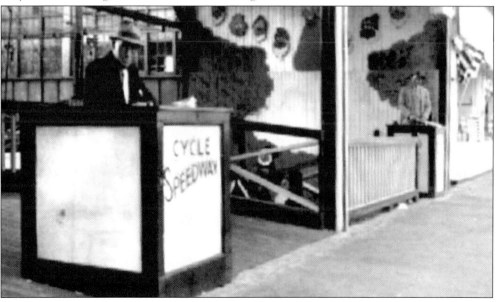

In an attempt to draw visitors into spending their hard-earned money, many amusement operators hired barkers. These men would deliver a sales pitch with the hopes of enticing customers to select their particular amusement. This added to the carnival-like atmosphere of the beach.

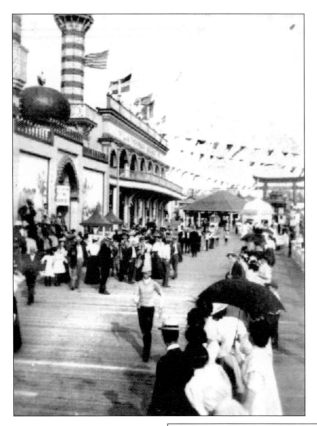

Revere's greatest attraction opened in 1906 and was named Wonderland Park. This amusement center was a predecessor of Disneyland and Six Flags. Long before Atlantic City had a boardwalk, Revere had a boardwalk at Wonderland Park that centered around a 115-foot, man-made lagoon.

Once they were in the park, customers had no need to leave. Aside from the amusements and attractions, vendors could be found along the boardwalk ready to sell food and ice-cold Moxie. The park was located where Wonderland Dog Track and North Shore Road are today.

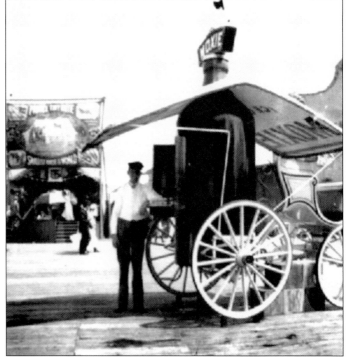

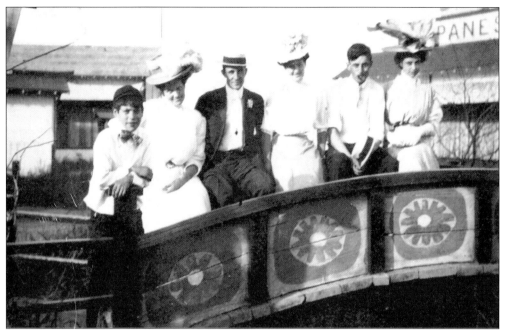

Wonderland Park was always seeking the most innovative amusements and shows. For a while, the park even had a Wild West Show with Buffalo Bill that consisted of American Indian raids and buffalo hunts. The visitors pictured here are standing on a bridge that led to the Japanese Village. The park closed in 1911 due to its exorbitant operating costs.

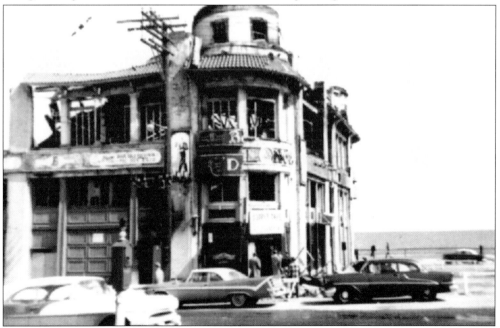

Crescent Gardens Ballroom was built in 1913 and was located on the corner of Revere Beach Boulevard and Shirley Avenue. For a short time, it was known as Moorish Castle. The building was also home to a movie theater. It was totally destroyed by fire in 1960 and was torn down. A park now occupies the site.

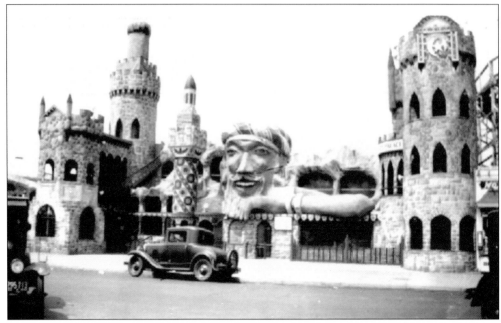

Bluebeard's Palace was probably the best-known fun house on the beach. This landmark thrilled young and old alike for over 30 years. The Shayeb family closed the fun house in the 1950s, and the building was torn down.

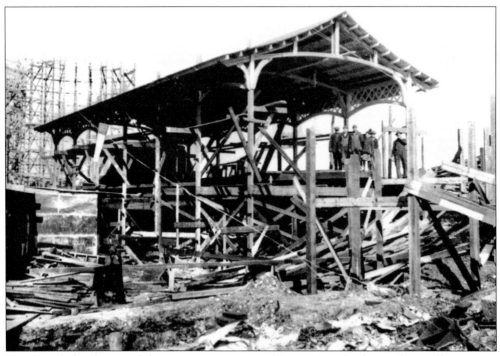

The Shayeb family owned the greatest attraction of Revere Beach, the Cyclone roller coaster. In 1924, construction began on the world's fastest and tallest coaster. The men standing on the platform were part of the construction crew that built the greatest thrill ride on the beach.

This pier was known as Ocean Pier when it was erected in 1910 at a cost of $100,000 by the Ocean Pier Company. The pier was built to establish steam service between Nahant and Revere. The building housed a ballroom, waiting room, nightclub, and penny arcade. The pier was destroyed by fire in September 1939. Only the pilings remain today.

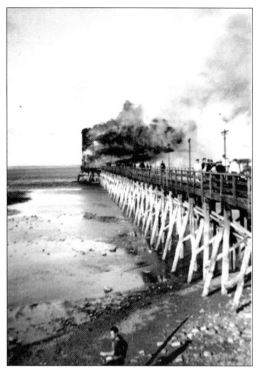

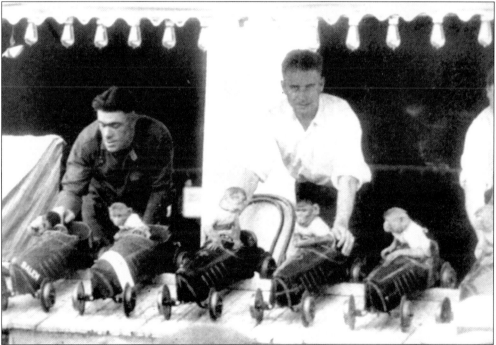

Vendors were always looking for unique ways to attract visitors to their stands. Pictured here are the operators setting up the monkey races. Live monkeys would sit in miniature soapbox racers while visitors bet on which car would finish first. This type of activity took place long before the establishment of the MSPCA.

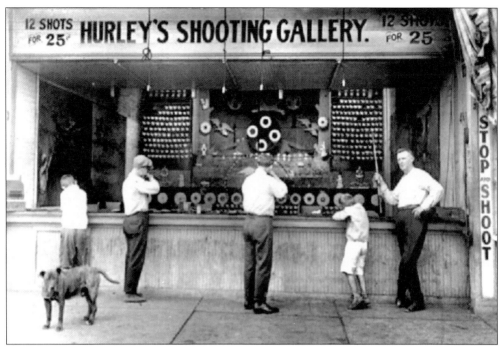

Visitors are enjoying the opportunity to win a prize at Hurley's Shooting Gallery. Many a young man would try his hand in order to win a prize for his date.

Camp Naefco Allen was located on the corner of Revere Beach Boulevard and Oak Island Street. The camp operated during the summer months and catered to children. Nothing remains of the camp.

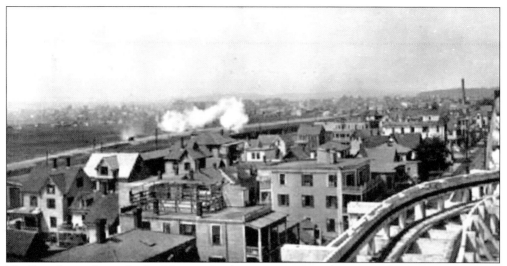

Thrill seekers who rode the Virginia Reel may remember this view of Baker Avenue. The tenements on Baker Avenue were torn down and their residents displaced under the guise of urban renewal. High-rise condominiums now occupy the site.

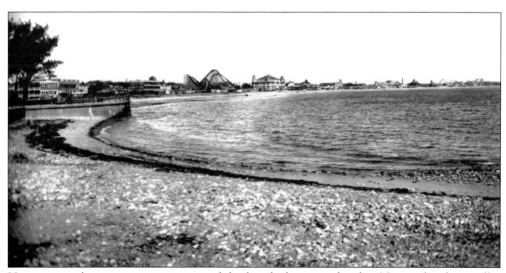

Here is a rarely seen panoramic view of the beach during its heyday. Notice the three roller coasters that emerge from the skyline. You can almost smell the salty air and cotton candy and hear the calliope music.

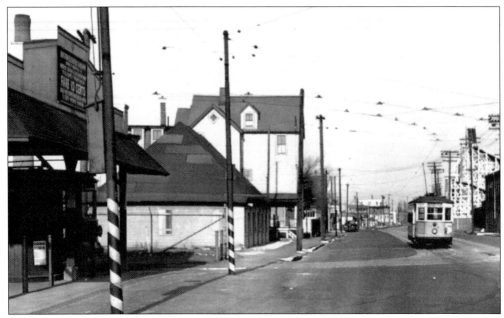

It is important to note that the amusements were not contained to just the boulevard. Ocean Avenue had lesser-known amusements throughout the years. Some people may remember the roller-skating rinks, Denny's restaurant, and Bob's Discount.

As the city evolved, so did the beach. The stands along the boulevard were no longer haphazardly strewn along the beach but were transformed over time into permanent structures.

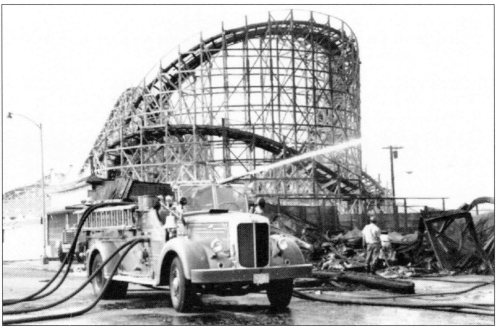

From the time it opened in the early 1930s, the Virginia Reel was billed as the most sensational ride in the world. This fascinating ride was a featured attraction on the beach. It has been estimated that over a million people enjoyed this ride during the years of its operation. Here we see the fire department extinguishing the blaze that destroyed the Virginia Reel in the 1960s.

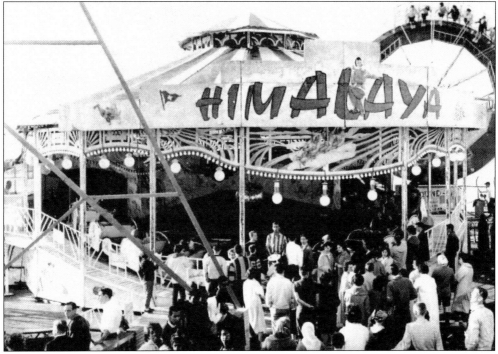

Locals may remember spending their free time as teenagers hanging out with their friends in front of the Himalaya. This fast-paced thrill ride was a big favorite on the beach.

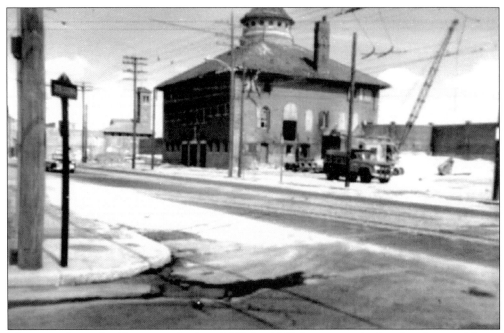

The original state bathhouse was built in 1897. By 1962, however, it had outlived its usefulness. Here we see construction crews hard at work razing the building. Another bathhouse was built on the same site in 1963, but that too has been torn down, and the site is currently used as a parking lot.

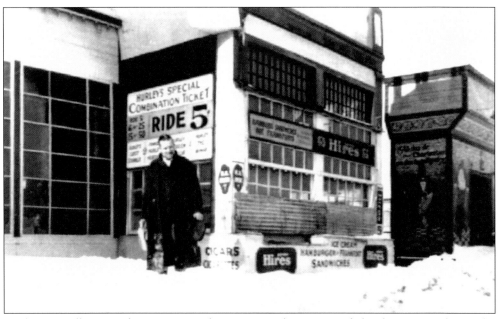

Hurley's Hurdlers was first constructed in 1896 and was one of the first carousels on the beach. It originally had bicycles on the revolving platform. As business increased, flying horses replaced the cycles. This photograph serves as a reminder that the amusements were a seasonal business due to the New England winters.

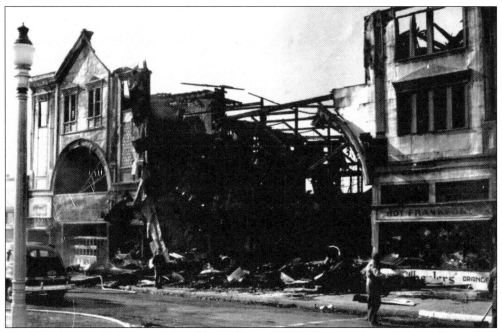

In November 1947, the original building of Hurley's Hurdlers was destroyed in a horrendous blaze. The original carousel had been sold and moved to Nantasket Beach in 1945.

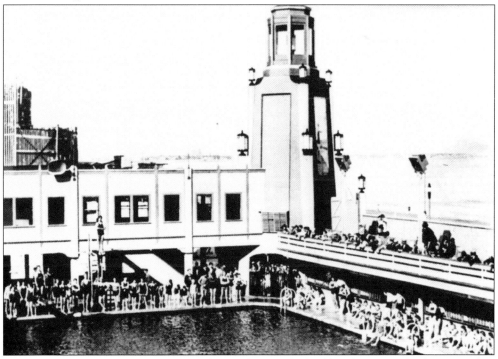

The Nautical was the brainchild of Herbert Ridgway. The building began modestly as a 50-foot structure. Eventually it grew to a 209-foot amusement complex. After a second fire in 1927, an Olympic pool was installed. Olympic tryouts and other swimming events were held here. Eventually the pool was turned into a popular scooter boat ride.

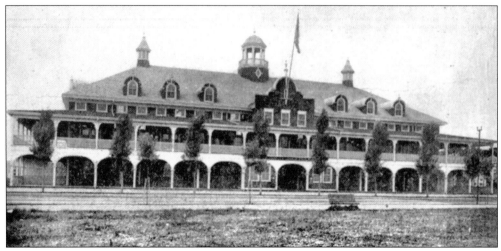

Condit's Summer Dancing Pavillion opened on June 17, 1904. This luxurious ballroom was built by J. Condit at a cost of $20,000. The Ridgway family purchased the property after Condit died and changed the name to the Spanish Gables. In the 1940s, the name was again changed to the Oceanview.

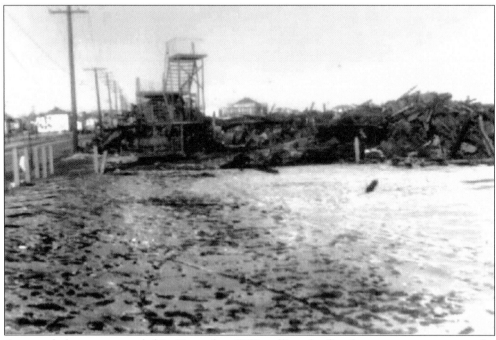

A general alarm was sounded in December 1959, calling the fire department to a spectacular blaze at the Oceanview. When the flames were finally extinguished, the building had been destroyed, and a Revere firefighter, Melvin Caissie, had been killed in the line of duty. This pile of rubble was all that remained. Atlantic Towers Apartments now occupies the site.

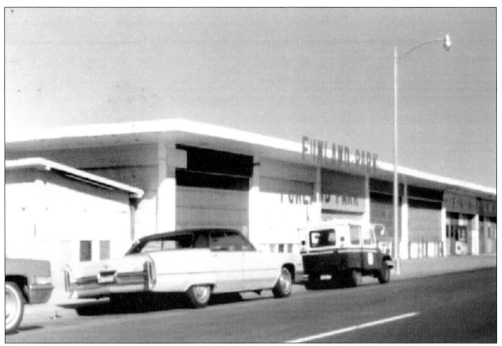

By the mid-1970s, the beach had lost its mystique. With the advent of air travel, families were no longer vacationing near home. Instead, they headed for destinations such as Disneyland. Beachside attractions, such as the Funland Arcade, became a hangout for local teenagers.

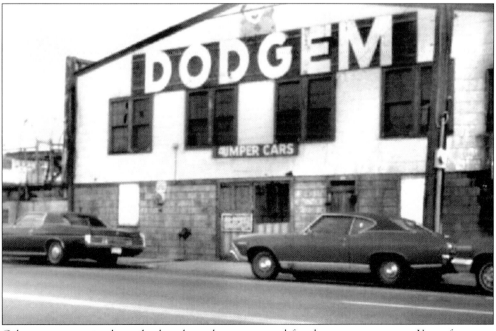

Other amusements along the beach no longer opened for the summer season. Year after year, the buildings and amusements gradually fell into disrepair. Their signs served only as reminders of what once was.

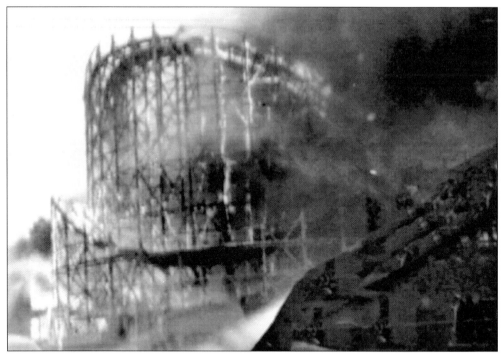

The greatest thrill ride on the beach was damaged by fire. This is an image of the Cyclone roller coaster burning in the early 1970s. Although the coaster had closed in 1969, people were hopeful that it would once again open. However, after this fire, the ride was torn down in April 1974 with a small crowd in attendance. The beach would never be the same again. It was the end of an era.

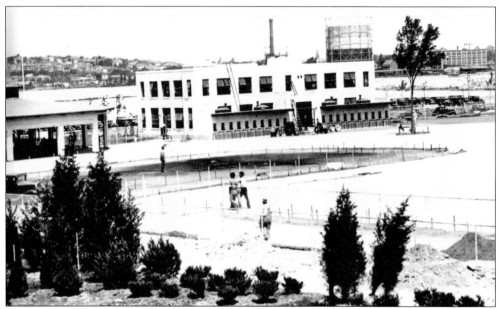

In 1935, Suffolk Downs racetrack was built. This track was not only New England's largest track but was also the most beautiful track in the country. Here is a view of the administration building and paddock area under construction.

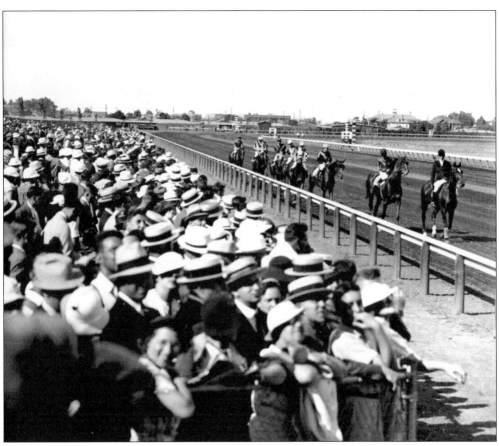

Enormous crowds were a common sight at Suffolk Downs. Seabiscuit ran here before winning the Triple Crown, and Britain's "Fab Four," otherwise known as the Beatles, performed here during the 1960s.

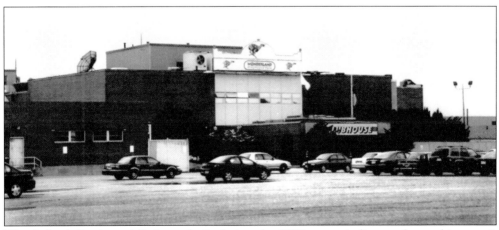

Wonderland Greyhound Park was built during the 1930s to capitalize on the working man's interest in gambling on dog racing. At one time, Wonderland was the premier greyhound park in New England, and it always had a packed house.

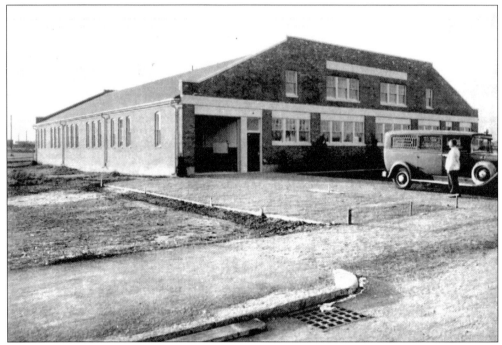

This building was owned by Wonderland Greyhound Park and was located where Stop and Shop is today. During World War II, it was used as an emergency hospital in case of an air raid. Wonderland even had gas stations in the parking lots to service customers.

The only reminder of the amusements at the beach that remains is the completely renovated train of Cyclone cars that Ed Gustat owns and keeps at Revere Rent A Tool.

Six

DINING OUT

People have always sought a break in the daily routine of life, and dining out was one of those breaks. Where you went depended on where you came from, how much cash you had to spare, and, sometimes, whether you had an excuse for getting away from Momma's kitchen. Many people may remember having lunch at Baker's or the Fernwood on Broadway.

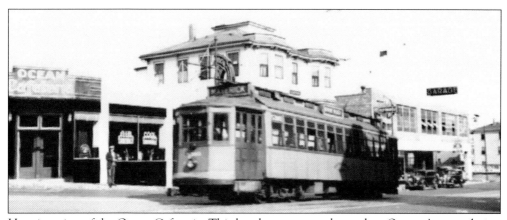

Here is a view of the Ocean Cafeteria. This luncheonette was located on Ocean Avenue during the 1930s. The building that housed the luncheonette has been torn down and replaced with the Banana Boat ice-cream stand.

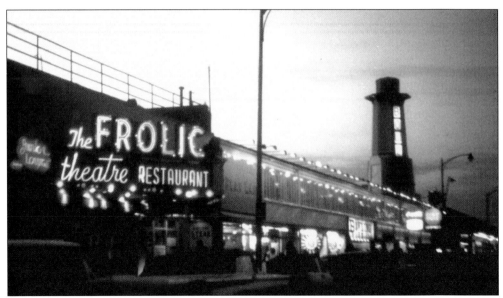

The best-known restaurant and nightclub was the Frolic Theatre Restaurant on Revere Beach Boulevard. The Frolic operated as a bar until the Della Russo and Cella families purchased the club in the 1930s. They immediately began turning the property into a world-class entertainment complex. During the late 1930s, when nationwide broadcasts of orchestras were at the height of popularity, Louis Prima broadcast from the Frolic.

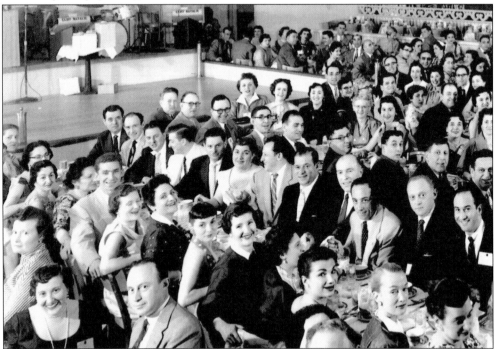

Some of the members of the Revere High School class of 1935 enjoy their 20th reunion at the Frolic. Many entertainers played here over the years, including Al Martino, Jerry Vale, Sammy Davis Jr., and Barbara Streisand. The blizzard of 1978 caused extensive damage to the club, resulting in the building being torn down.

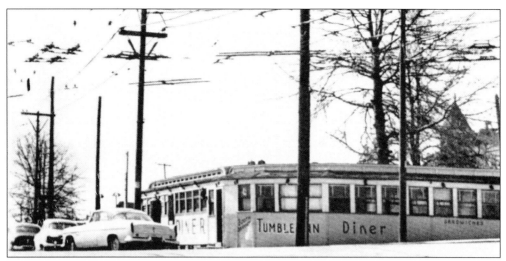

The Tumble Inn Diner was located on the corner of Beach Street and Ocean Avenue. Here, a person could get a hearty meal at a reasonable price. This diner was a landmark on Ocean Avenue. It has been torn down and replaced with an office and medical building.

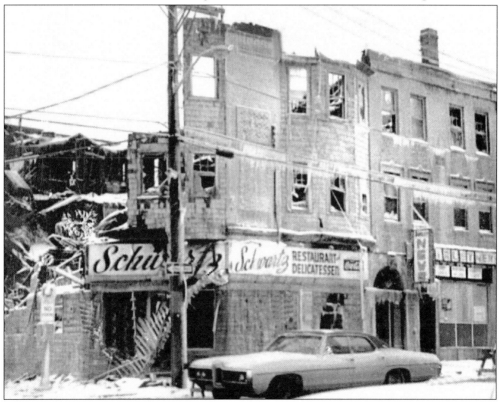

Renowned throughout the city for its corned beef sandwiches, Schwartz's Delicatessen, located on the corner of Shirley Avenue and North Shore Road, was a favorite among many. Crowds of loyal customers flocked into Schwartz's no matter what time of day. It was a favorite after-hours stop after local bars closed for the night. Sadly, it was totally destroyed by fire and replaced with a parking lot.

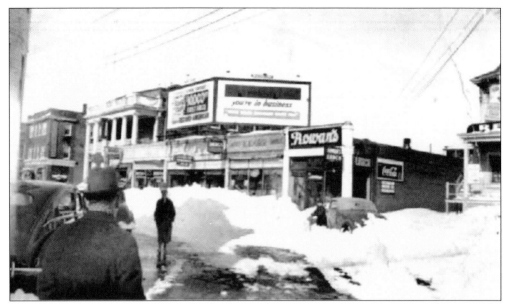

This is a view of Shirley Avenue, looking west from Orr Square. Rowan's Luncheon can be seen on the corner next to the Veterans of Foreign Wars (VFW) building, which has since been torn down and replaced by a parking lot. A liquor store is now located in the building that once housed Rowan's Luncheon.

The Shamrock Diner was a local favorite among the residents of Beachmont. The diner was located on the corner of Winthrop Avenue and Washburn Avenue. Beachmont Roast Beef currently occupies the building.

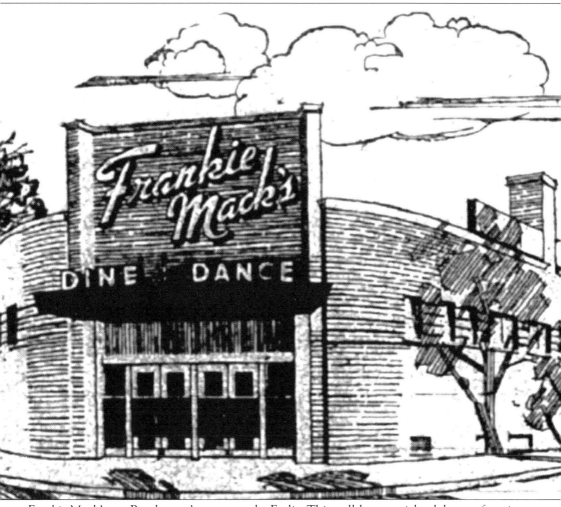

Frankie Mack's was Beachmont's answer to the Frolic. This well-known night club was a favorite among Beachmont citizens, who could have an affordable night out and see a floor show here. An after-hours club also operated in the basement. The building has been remodeled and is currently occupied by the Revere Family YMCA.

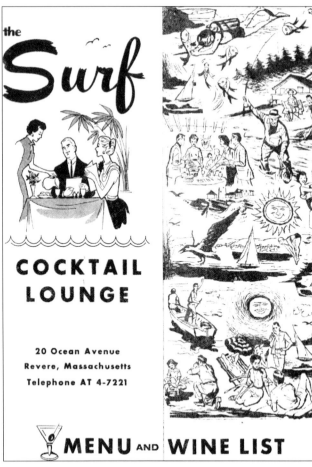

The Surf Cocktail Lounge was located at 20 Ocean Avenue. This was an upscale restaurant that provided affordable food in a romantic atmosphere. The building has been torn down, and the lot remains vacant at present.

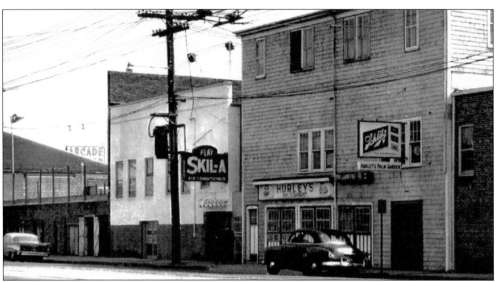

Many beachgoers may remember Hurley's Palm Garden. This is a view of the lounge from the Ocean Avenue entrance. Today, nothing remains of this once popular night spot.

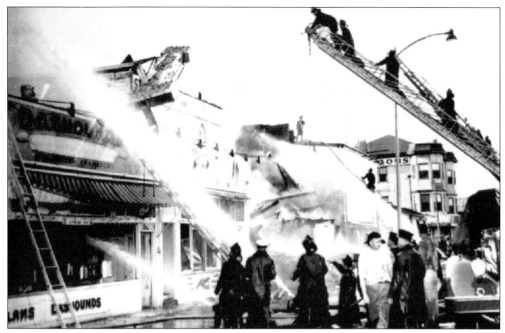

A disastrous fire destroyed Lewis' American Café, which was located at 107 Revere Beach Boulevard. This beloved eatery had been on the beach since 1908. A floor show and dancing took place every weekend.

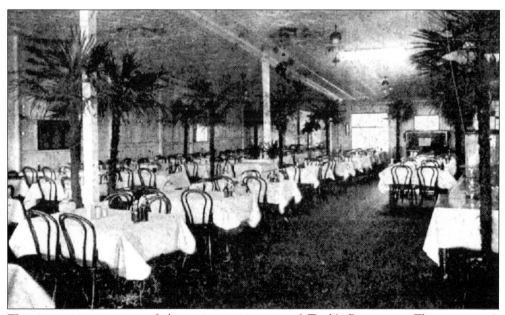

This is an interior view of the main seating area of Trask's Restaurant. The restaurant's proprietor, Howard Trask, was also co-owner of the Derby Racer roller coaster. Nothing remains of the coaster or the restaurant.

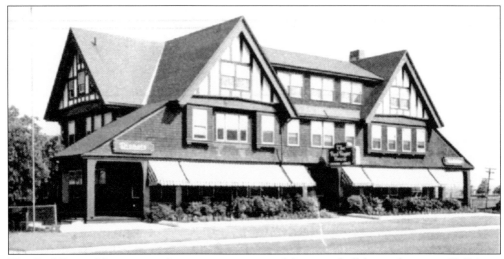

The Paul Roger House was a favorite restaurant and function hall located next to Kelly's on Revere Beach. This restaurant was favored by local couples for wedding receptions. Originally, the building was known as Mother's Rest and was owned by the Methodist Church. The building has been torn down, and the Jack Satter House now occupies the site.

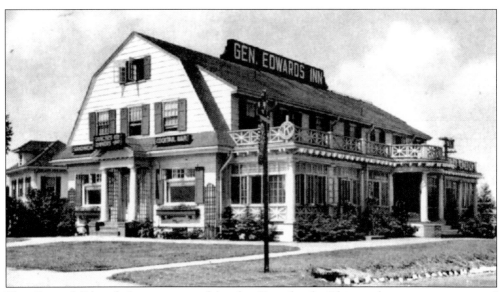

The General Edwards Inn was owned by the Cary family. This modest restaurant catered to families seeking good food for an economical price. The building was torn down, and condominiums now occupy this site on the boulevard.

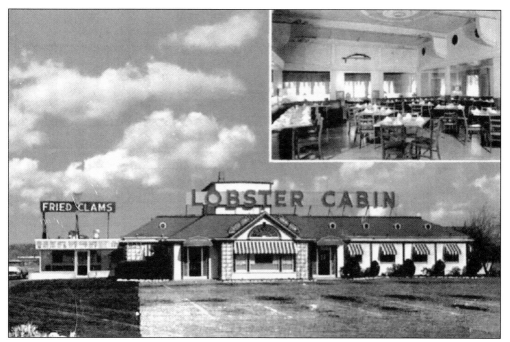

This local favorite was located on North Shore Road near the General Edwards Bridge. Patrons enjoyed great-tasting seafood at an economical price. The restaurant was torn down and replaced with another restaurant building.

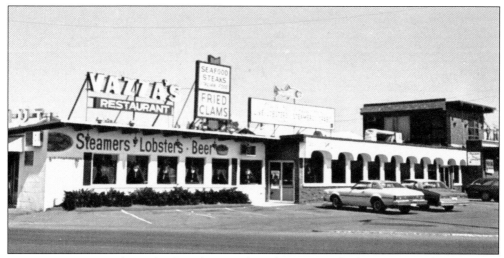

Vazza's Restaurant was located at Broadway Circle and Squire Road. The restaurant also had a fresh seafood store located next door. The restaurant was torn down and replaced by a gas station.

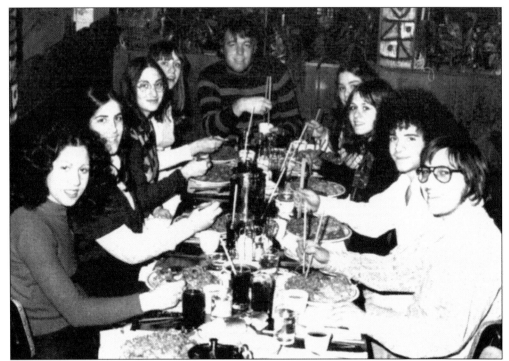

Here we see a group of satisfied patrons enjoying a meal at the China Lantern restaurant, which was located on Ocean Avenue. The Lantern, as it was affectionately known, was a popular establishment during the 1960s and 1970s. Sadly, the restaurant is gone, and the building remains vacant at present. No longer will beachgoers smell the aroma of the Orient as they stroll down the boulevard. (Courtesy Donald Craig.)

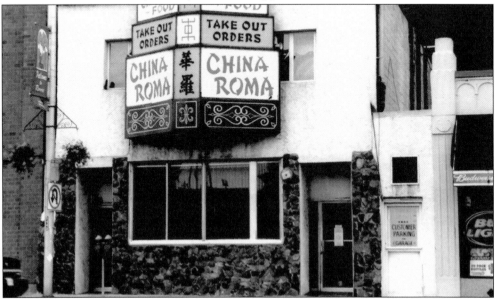

A local favorite and a landmark on Broadway is China Roma. Over the years, residents have flocked here for a taste of the Orient. Originally, the restaurant had an additional dining room on the second floor, and the waitstaff had to carry the food up the stairs.

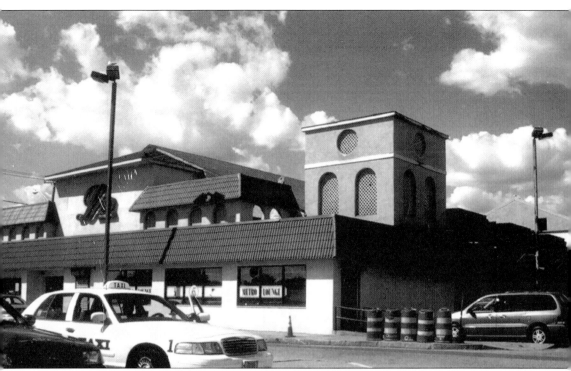

Joe Destefano created and built the Wonderland Ballroom in 1961. The ballroom quickly became New England's premier dance spot. By 1985, the ballroom had fallen on hard times. The MBTA attempted to purchase the building to use the land for a parking lot. When this became known, a group called Wonderland Dancers was formed to save the ballroom, and with the help of several legislators, the ballroom was spared from destruction. The building has been remodeled and now houses the Lido.

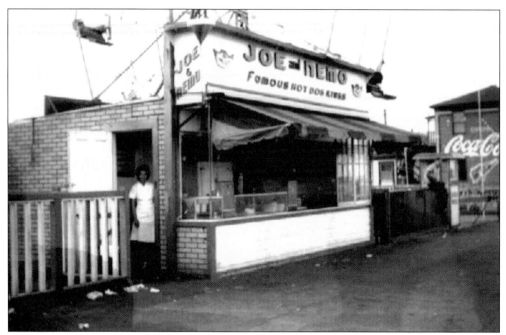

No list of restaurants in Revere would be complete without mentioning Joe and Nemo's hot dog stand, which was located on the boulevard. No matter what their financial status, everyone enjoyed sinking their teeth into a Joe and Nemo's hot dog. This eatery truly had a vast democratizing effect on the patrons of the beach.

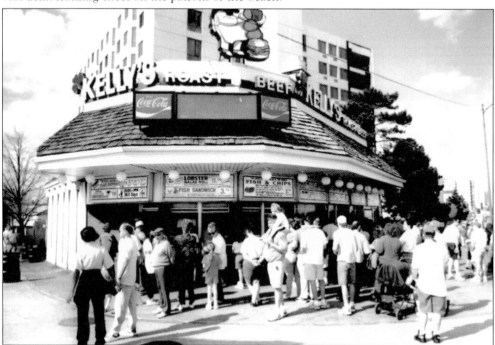

The only surviving eatery from Revere Beach's heyday is Kelly's Roast Beef. Although the restaurant's prices have risen considerably in order to adapt with the times, it is still considered a must-visit by beachgoers.

Seven

HOUSES OF WORSHIP

Religious worship has always played an important role in the lives of Revere's citizens. Each congregation, parish, or temple served as a source of identity for the members within the community.

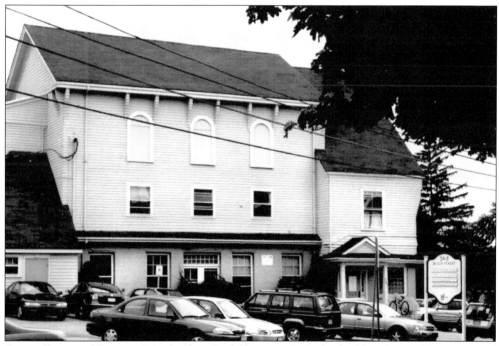

Originally named Rumney Marsh Church of Christ in 1710, this building has undergone several renovations. During the 1800s, the congregation changed their denomination to Unitarian. The congregation remained until 1919, when the building was sold to the Masonic organization. Currently, the building is occupied by the North Suffolk Mental Health Association.

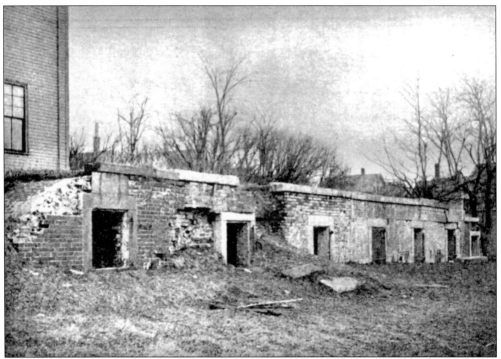

These tombs, built in 1806, belonged to the Unitarian church. In 1912, the tombs were demolished, and the remains were moved to the Rumney Marsh Burial Ground when Cary Avenue was built.

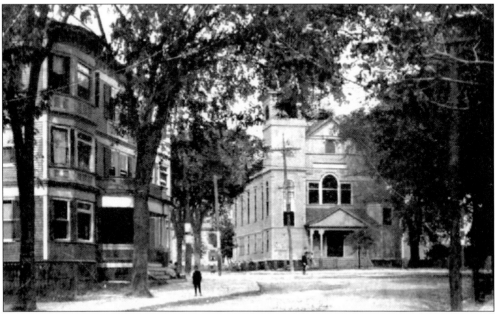

This is a view of Church Square, looking north from Beach Street. Originally an Orthodox church, this building was officially dedicated on January 17, 1850. The building was raised and a vestry was added in 1884. On January 29, 1885, the church was rededicated and the name was changed to First Congregational Church.

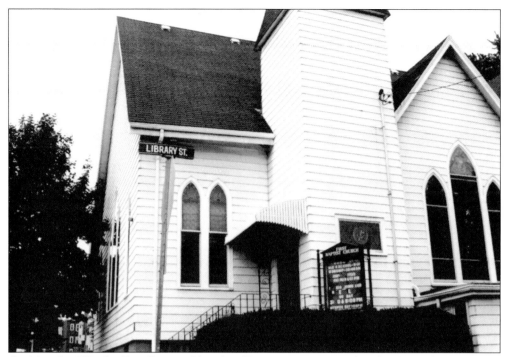

On May 5, 1877, the First Baptist Church of Revere was organized with 15 members. Services were held in the town hall until a chapel was built on Winthrop Avenue in 1884. The present church was dedicated on January 17, 1893. It is believed that the bell is a Paul Revere bell.

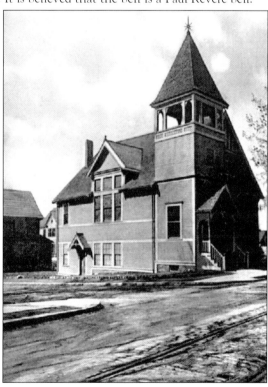

In October 1878, Almira Steele began the first church in Beachmont in a café that was owned by the Boston Land Company. According to the congregational polity, a church of 14 members, including Steele, was organized in 1881 under the name Union Evangelical Church. The church was admitted to the Suffolk North Conference of Congregational Churches in 1891, and its name was changed to Trinity Congregational Church on December 28, 1897. The building was located on Winthrop Avenue and is no longer used as a church.

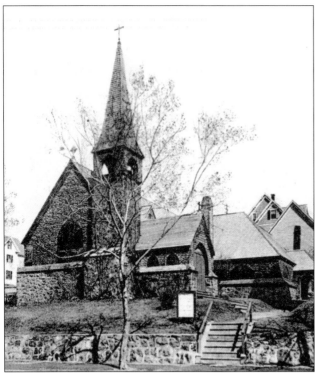

On February 8, 1885, the first Protestant Episcopal Sunday service was held in Beachmont. Parishioners in Beachmont and Winthrop raised $10 a week and hired Rev. J. C. Hewlett of Boston as their resident pastor. A dedicated band of church women led by Mrs. T. A. Murray was instrumental in acquiring an altar, surplice, cassock, and stole. In April 1886, St. Paul's became the official name of the church. In 1887, Rev. H. B. Wood and his family moved to Beachmont and construction began on the church building. The church has since closed.

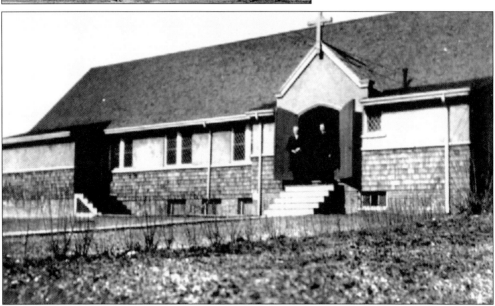

This congregation arose out of necessity. In 1902, two gentlemen connected with St. Paul's Episcopal Church were tired of the journey to Beachmont for Sunday service. They hired a hall on April 13, 1902, and started a Sunday school with 40 students, naming it the Revere Episcopal Mission. By September, Sunday service was being held as well. Attendance grew, and the Episcopal Church formally established the church as a mission in 1903. A building committee was established in 1910, and the church was consecrated by Bishop Lawrence on February 1, 1911. St. Ann's Episcopal Church has closed, and doctor's offices now occupy the building.

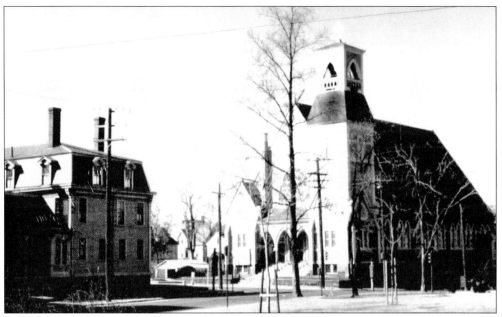

From 1885 to 1888, the Immaculate Conception Church held its services in the town hall. On July 1, 1888, the cornerstone was laid for a church on the corner of Winthrop Avenue and Beach Street. By December, the basement was completed, and the first service was held in the building. After the church was completed, it was officially dedicated on May 28, 1893.

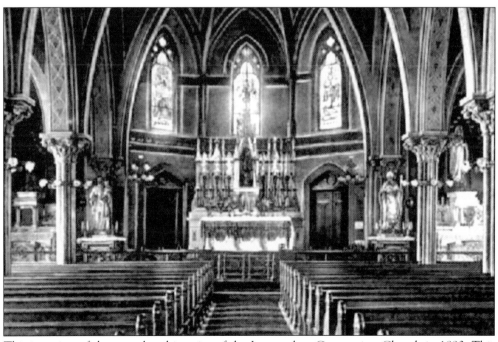

This is a view of the completed interior of the Immaculate Conception Church in 1893. This building has since been torn down, and Sonny Meyers Park now occupies the site. A new church was built across the street where the former high school once stood.

This building was located directly across from the Immaculate Conception Church and was used as the parish rectory and later as a convent for the Sisters of St. Joseph, who taught in the Immaculate Conception school. The building was torn down when the new convent was built. The site is currently the schoolyard for the Immaculate Conception school.

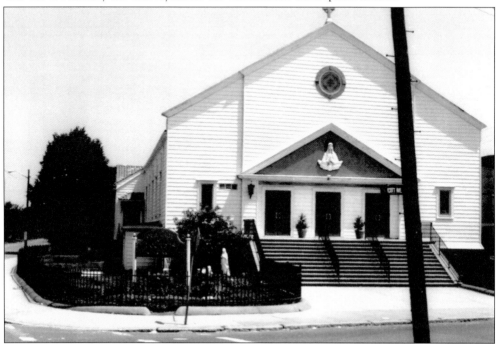

Our Lady of Lourdes church was erected in 1902 and officially dedicated in November of that year. This parish has served the Beachmont community for over 100 years. Sadly, the church has been placed on the closure list by the Boston Archdiocese.

The Associate Church and Lay College were located on Shirley Avenue. On August 6, 1886, the church and college opened their doors. Lay College was founded to train young men to become ministers. The college was later transferred to Chicago. The church was sold on October 24, 1913, and became the Armenian Congregational Church. This site is now occupied by several small stores.

In 1892, the Methodist Episcopal Society erected a church on the corner of Shirley Avenue and Nahant Avenue. The building was sold in 1916 to the Congregation Tiffereth Israel. It is still in use as a Jewish synagogue. In 1917, a new church was erected on the corner of Beach Street and Janvrin Avenue and was in constant use by the Methodist parishioners until the church closed in the 1980s.

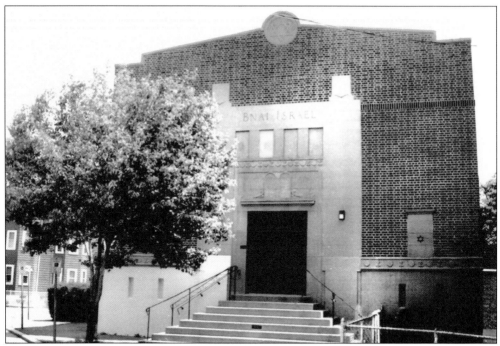

The first Jewish services in Beachmont were held at Parker Hall at Depot Square in 1906. In 1925, Temple B'nai Israel was erected at the corner of Dolphin Avenue and Wave Avenue. The building is still in use as a synagogue.

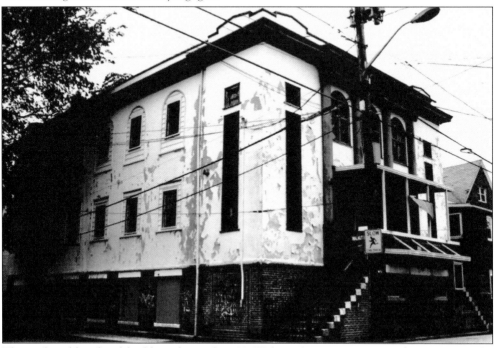

This rather dilapidated building, located at 89 Walnut Avenue, was once the synagogue for the congregation Ahavas Achim. Sadly, this once thriving temple has closed due to its lack of attendance. The building remains as a reminder of this area's Jewish history.

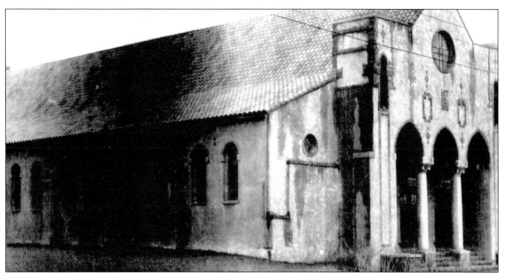

Shortly after his appointment as pastor of the Immaculate Conception parish, Fr. Timothy Holland had the foresight to note the need for a parish in the beach district. In 1925, construction began on St. Theresa's church. In March 1927, the new church was dedicated by Father Holland. Over the next 10 years, the parish experienced rapid growth. The church served as a mission for the Immaculate Conception parish until Cardinal O'Connell announced in 1937 that Rev. Michael J. Houlihan would be the new pastor of St. Theresa's church. The church has since closed.

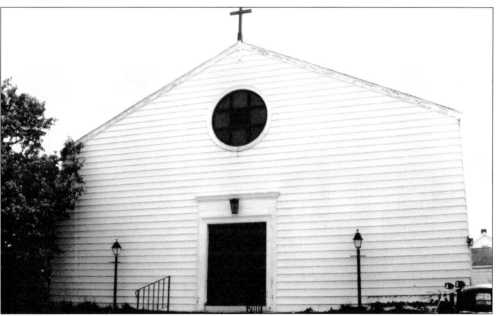

The parish of St. John Vianney grew out of a need to contain the overflow of St. Theresa's on Revere Street. The parish originally consisted of approximately 200 families. The church was located at the corner of Harrington Avenue and Revere Beach Boulevard and contained a hall in the basement, an auditorium, and a large choir loft. When the church opened on October 28, 1951, Archbishop Richard Cushing blessed the parish. Unfortunately, this parish was closed. The building is now privately owned.

In 1903, the Italian community of Revere felt that the time had come to have an Italian Catholic priest provide for their religious needs. Dominic Cataldo obtained permission from Bishop O' Connell to form a parish. Carmine Pierno donated the use of the first floor of his home on Revere Street for mass.

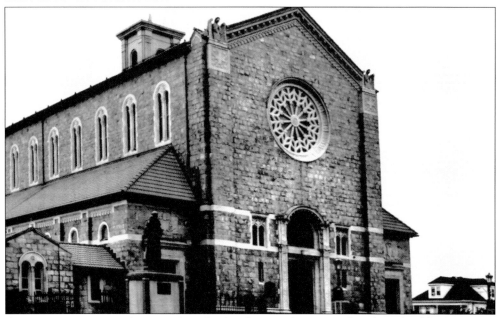

Appropriations were made to purchase land and erect a basement church in the fall of 1905. By 1924, the congregation had outgrown the church, so it was decided to build a new church that could accommodate 10,000 parishioners. The new church site was diagonally across the street from the basement church. The land was secured with the help of Mayor Noone, and in the summer of 1925, the ground was blessed and the foundation laid. On June 2, 1926, the church was opened for services. The elaborate interior was finally completed in 1948. St. Anthony's church was modeled in the Tuscan style and is one of the most beautiful edifices in the country.

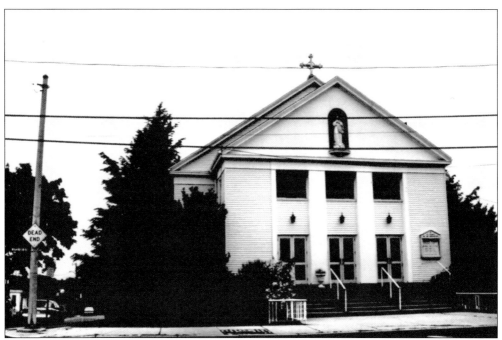

St. Lucy's was started as a mission of St. Anthony's Italian parish. The chapel, located at the junction of Malden Street, Washington Avenue, and Copeland's Corner, was formally dedicated in July 1948. The first pastor of the new church was Fr. John O'Leary. The church was later renamed St. Mary of the Assumption and was rededicated.

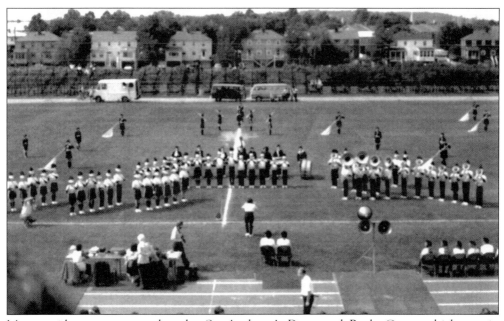

Many residents may remember the St. Anthony's Drum and Bugle Corps, which was in operation from the 1960s to the 1980s. The corps is sadly missed by residents during the Columbus Day parade each year. (Courtesy Lucy Patti.)

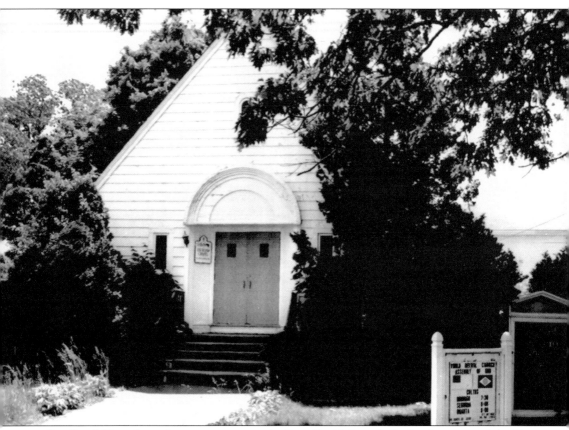

Bay Road Chapel was begun as a mission by Rev. Dr. Nelson S. Burbank, pastor of the First Congregational Church of Revere. It was originally intended as a Baptist Sunday school. The school continued to grow, and Sunday service was established in November 1931. The church had several locations through the years until finally settling in the Point of Pines, where it remains an active church today.

Eight

A FINAL LOOK

When people grow older, they often sit back and think of their younger years, looking back over the days that have come so quickly one after the other. They reflect back to the places and things that they were familiar with and wonder just when certain things happened. The city of Revere has changed dramatically over the years. If we look hard enough, much of what is left of Revere's history can still be found around the city.

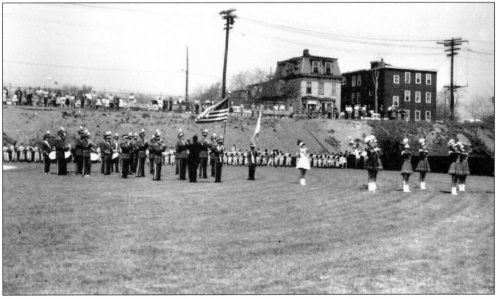

Organized sports in Revere were unheard of until the Revere Little League was formed. This is a view of McMackin Field on opening day in 1956. The two houses in the background have since been torn down and replaced with elder housing. The field has undergone extensive remodeling and is considered one of the most beautiful Little League fields in the area.

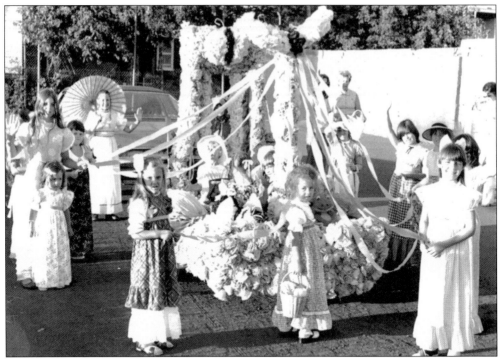

During the 1970s, Revere's Parks and Recreation Department had a program in which the youth of the city built parade floats in the neighborhood parks. Once completed, the floats would make their way to Harry Della Russo Stadium, where prizes were awarded for the best float. (Courtesy Revere Parks and Recreation Department.)

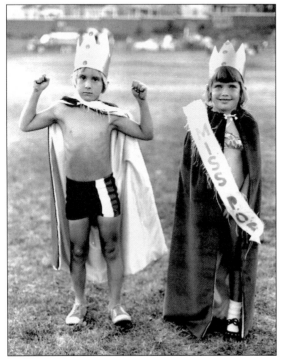

At the end of the parade, the parks and recreation department would select a king and queen of the parade. These children are obviously exuberant about their newly acquired status. (Courtesy Revere Parks and Recreation Department.)

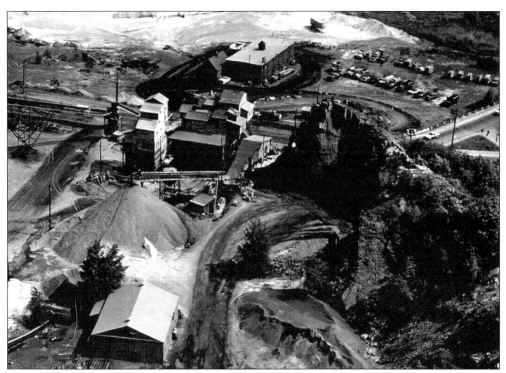

This is an aerial view of the former Rowes Quarry, which was located on Salem Street in north Revere. The quarry closed and was torn down to make room for an apartment complex.

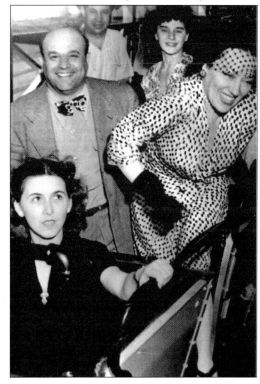

Through the years, many notable personalities have visited Revere. Gloria Swanson is pictured here exiting an amusement ride on Revere Beach.

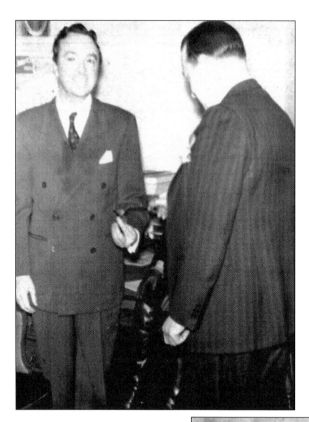

Jack Haley, who played the Tin Man in *The Wizard of Oz*, lived in Revere when he was a child. Mayor Gillis is seen here presenting Haley with a key to the city.

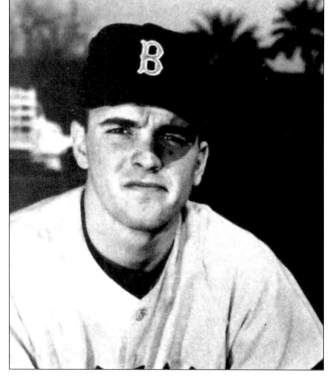

Baseball star Tony Conigliaro was born and raised in Revere. He and his family moved out of Revere while he was still a small boy. When he made his first major-league debut at Fenway Park, the city of Revere felt as much pride as his parents did. Conigliaro continues to be a beloved part of Revere's history.

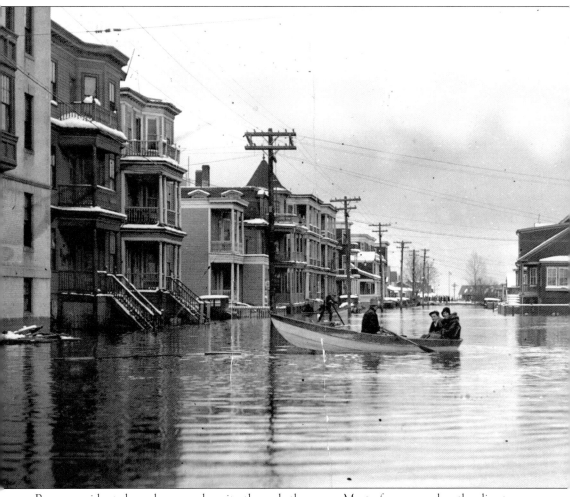

Revere residents have known adversity through the years. Most of us remember the disastrous blizzard of 1978 and the rebuilding that took place afterward. This image is not of Venice, but rather of Jones Road after the 1932 flood. No matter what natural disaster may strike, Revere residents maintain their sense of humor.

The following is a list of Revere residents who gave their lives in the 20th century to ensure a peaceful tomorrow: (World War I) Max Achenback, William Batstone, John Breen, Charles N. E. Brown, John R. Butler, William J. Butler, Euplio Cerrone, Joseph W. Chamberlain, Pasquale Colangelo, Douglas C. Cummings, Joseph DiItalia, Frank P. DiPesa, Richard D. Donnelly, Francis J. Driscoll, Frank Erricolo, John F. Fitzpatrick, Charles N. Fredericks, William H. Hartley, Raymond Lawrence, Carl W. Mabie, Samuel P. Mahoney, Richard R. Marshall, John Mooney, William Murphy, John Pesa, Louis Sandler, Samuel Sandler, Albert W. Smith, James R. Sweeney, William Ungvarsky, and Earl B. Welch; (World War II) Warren E. Allen, William E. Allen, Frank J. Alvino, Salvatore J. Bagnulo, Frederick C. Baldwin, Joseph Beaker, Michael Begley, Edward Bloom, Phillip F. Boyd, William S. Boyd, James L. Brandano, Italo J. Breda, Leroy E. Brown, Robert P. Brown, Milton Bubis, Francis Burns, Richard J. Chouinard, Loftus L. Christianson, Alfred J. Conley, John A. Conley, Lloyd F. Coolidge, Adolph F. Cormier, Eugene Coscia, Wilfred F. Cote, Robert E. Cotter, Salvatore Crivello, Paul W. Cronin, William J. Crough, Robert Cummings, Robert P. Cuozzo, Fred E. Deacon, Victor D. DeGuglielmo, James V. DeMarco, Thomas DeSisto, Albert Destoop, Antonio DiGregorio, Augustine A. DiPietro, Dante DiPrizio, Arthur DiStasio, Peter DiStasio, Daniel F. Doris, Charles D. Dugan, George A. Elwell, John Famiglietti, Robert Fecitt, Samuel Feldman, Christopher Feragamo, Charles J. Fietz, John V. Fitzgerald, John H. Foley, Francis J. Foye, Nicholas Frammartino, Hallet H. Fraser Jr., Edward H. Friedman, Harry J. Garrity, Harold Gay, Edward Z. Gelman, Robert Gladstone, Samuel H. Gordon, Joseph Gorfinkle, Julius Greenberg, John F. Hannigan, Joseph H. Harrington, David P. Hartigan Jr., Herbert S. Hill Jr., James J. Hill, George Horblitt, Joshua R. Howard, Maurice W. Hudlin, John E. Hurley, William A. Janvrin Jr., Charles F. Jensen, Joseph H. Joyce Jr., John D. Kane, Isadore Kaplan, Harold E. Kendall, Chester H. Kenney, Hubert H. King, Alfred Kniznick, Elwin Knowles, John E. Knox, Carroll Kummerer, Thomas

F. Landry, Stephen M. Langone, Simon Lee, John J. Lehmann, Raymond Lepore, Herbert Levine, Douglas J. MacDonald, Andrew J. Mantine, Paul S. Maslowski, John W. Mastrachi, John A. Mastromarino, John N. Mayor Jr., Thomas J. McCarthy, Charles F. McClusky, Robert F. McDonald, Charles G. McMackin, Joseph E. Messina, John H. Minichino, Irving Mintz, Seymour A. Molin, Frank A. Molino, Domenic D. Morra, Joseph L. Mottolo, Joseph O'Brien, Christopher Paragone, Edward J. Parsons, Kenneth J. Patenaude, Lugo Pennachio, Francis N. Petro, William Pidgeon, James F. Quinlan, Fred L. Raymond, Carmine M. Reppucci, Alfred S. Romeo, Harold Rosenbaum, Melvin E. Resenberg, Samuel N. Rubinovitz, Armando Ruggiero, Alexander A. Russo, Anthony G. Sarno, Salvatore P. Scaffidi, John A. Sciaraffa, Thomas F. Shaughnessy, Gerald P. Shaughnessy, Irving B. Sherman, George H. Singer, Kenneth G. Snow, Peter Stamulis, Edward Steinman, Robert Struthers, George C. Sullivan, John Sullivan, Gerald Swerling, Carl M. Thomajan, Sidney Toressen, Raymond R. Venezia, Thomas Von Holzhausen, Israel Weinberg, Woodrow W. Wilkins, V. Howard Woodell, Harry Zassman, and Milton L. Zelmeyer; (Korean War) Shirley B. Andrews, Hugo F. Carozza, Frank Charido, Gerald Chieppo, Joseph Concannon, Bernard A. Kinnally, Bernard Kniznick, Robert S. Mauro, William A. Shiveree, and Walter Smart; (Vietnam Conflict) Kenneth G. Brown, Robert L. Blais, James L. Delmont, Sebastian E. DeLuca, Martin L. Gillespie Jr., John M. Glasser, Arthur R. LeGrow Jr., Alan J. O'Brien Jr., Walter S. Olinsky Jr., Stephen J. Penta, Thomas W. Whitten, and Robet Karl Lavigne. Special mention should also be made of Revere resident Marianne MacFarlane, whose life was tragically cut short by the terrorist attacks of September 11, 2001. Natalie Janis Lasden and Raymond J. Rocha, both of whom had ties to Revere, also died due to the events of September 11. May the quote "God gave us memories so that we may have roses in December" be a comfort to the families of those mentioned above. They will be forever remembered by a grateful city. (Courtesy Rich Baillie.)

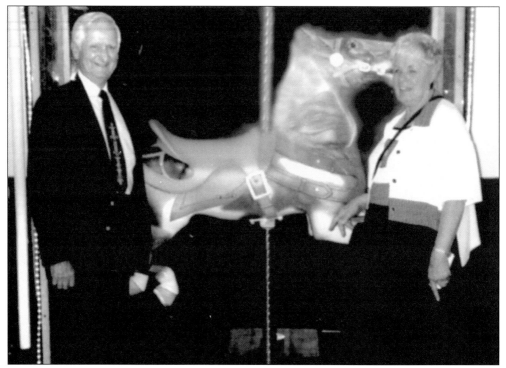

Peter McCauley is considered by most to be the official historian of Revere Beach. He has been instrumental in helping to get the beach listed on the National Register of Historic Places. He has authored numerous books about the beach, created a renewed interest in the history of America's first public beach, and is a treasured citizen of Revere. His books are in as much demand as are prints from local artist Norman Gautreau's paintings of the beach. Mary McCauley, Peter's wife, is on the right.

Once the Boston Archdiocese acquired the former high school site from the city upon which to build a new church for the Immaculate Conception parish, concerned citizens began to attempt to save the former rectory. The building was in terrible disrepair and required total renovation. The Revere Society for Cultural and Historic Preservation entered into a 99-year lease with the city and began to rehabilitate the deteriorating structure. Through fund-raising efforts, grants, and private donations, the costs were absorbed and the work completed.

Jim Russo is seen here working hard on refurbishing the front porch of the old Immaculate Conception rectory. He and his family were an outstanding asset in resurrecting what was formerly a blot on the landscape and transforming it into the pride of the community once again.

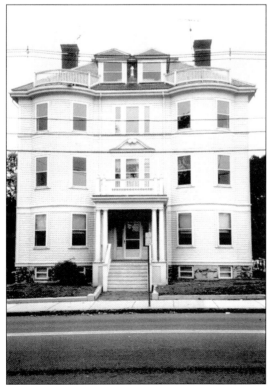

The 100-year-old former rectory now houses a museum and the offices of the Revere Society for Cultural and Historic Preservation. The museum is open Saturdays. Building rentals are available for functions. A gift shop is also housed within the premises. The building has recently been placed on the National Register of Historic Places through the efforts of Mayor Thomas Ambrosino and the Revere Society for Cultural and Historic Preservation.

In the decades that followed World War II, sinuous ribbons of concrete lured young Revere residents to explore and then colonize the nearby suburbs. Revere had lost many of its institutions and important pieces of its urban fabric over the years. Amusement entrepreneurs had opted to sell beachfront property to condominium speculators rather than rebuild. Younger citizens were buying the blarney about the suburbs; they were buying cars and moving out. Filling the housing vacuum left behind were newcomers, many of whom were immigrants seeking a better tomorrow just as their predecessors had. It was another wave of resettlement for Revere. But rich resources unique to Revere were forgotten. Many of Revere's sons and daughters have been dispersed across the breadth of the land, one day to think back on how life had been once in Revere.